Approaching Design through Nature

The Quiet Joy

This book is for Nicholas and Sean,
whose joys are just beginning

Approaching Design through Nature

The Quiet Joy

Grace O. Martin

Preface by Esther Warner Dendel

A Studio Book · The Viking Press · New York

Library of Congress Cataloging in Publication Data
Martin, Grace O. 1917– Approaching design through nature. (A Studio book) Bibliography: p. Includes index. 1. Textile crafts. 2. Design, Decorative. I. Title.
TT699.M39 746 77–619
ISBN 0-670-12980-1

Text and black-and-white illustrations printed in the United States of America. Color illustrations printed in Japan.

With the exception of those individually credited in the legends to the illustrations, all photographs in this book are by Robert B. Brown.

The author wishes to thank the following publishers and persons for their kind permission to reprint in this volume excerpts from the books and poems listed:
A. S. Barnes and Company, Inc., and Thomas Yoseloff Ltd: *With John Burroughs in Field and Wood* by Elizabeth Burroughs Kelley. Elizabeth Coatsworth Beston: *The Outermost House* and *Of Herbs and the Earth* by Henry Beston. Robert Bly: "A Late Spring Day in My Life" and "Approaching Winter" from *Silence in the Snowy Fields* by Robert Bly. Thomas Y. Crowell Company, Inc.: *Hummingbirds* by Walter Scheithauer. Copyright © 1967 by Thomas Y. Crowell Company. Department of Northern Affairs and Natural Resources: Eskimo song, "Aii, Aii," translated by Tegoodligak, from *Canadian Eskimo Art*, edited and published by Department of Northern Affairs and Natural Resources, Ottawa, Canada, 1954. Dodd, Mead & Company: *Journey in Green Places* by Virginia Eifert. Dodd, Mead & Company and Sidgwick & Jackson Ltd: "In Examination" by Rupert Brooke. Doubleday and Company, Inc.: "Christmas in India" by Rudyard Kipling from *Rudyard Kipling's Verse, Definitive Edition.* Doubleday & Company, Inc., and Faber and Faber Ltd.: "The Rose" by Theodore Roethke, copyright © 1964 by Beatrice Roethke, Administratrix of the Estate of Theodore Roethke; "The Shape of Fire," copyright 1947 by Theodore Roethke; "I'm Here," copyright © 1956 by Theodore Roethke; "Slow Season," copyright 1939 by Theodore Roethke, all from *The Collected Poems of Theodore Roethke.* Harper & Row, Publishers, Inc.: *The Hill of Summer* by J. A. Baker. Harcourt Brace Jovanovich, Inc.: the poem "To Know the Dark" and lines from "The Man Born to Farming," "The Heron," and "On the Hill Late at Night" from *Farming, A Hand Book* by Wendell Berry; also "Wanderlust" from *Blue Rhine, Black Forest* by Louis Untermeyer. Harvard University Press: *The Old House at Coate* by Richard Jefferies, edited by Samuel Looker, published 1948. Houghton Mifflin Company: *The Edge of the Sea* by Rachel Carson; "Snow Flakes," from *The Complete Poetical Works of Henry Wadsworth Longfellow*; and *A Cup of Sky* by Donald Culross Peattie. Jonathan Cape Limited: *The Essential Richard Jefferies* by Richard Jefferies, selected and with an Introduction by Malcolm Elwin. Alfred A. Knopf, Inc.: "The Secret of Life" from *The Immense Journey* by Loren Eiseley, copyright © 1957 by Loren Eiseley; *Runes of the North* by Sigurd F. Olson, copyright © 1963 by Sigurd F. Olson. Little, Brown and Company in association with The Atlantic Monthly Press: *Driftwood Valley* by Theodora Stanwell-Fletcher. Longman Group Limited: *The Story of My Heart* by Richard Jefferies. McClelland and Stewart Limited: Eskimo song from *Seasons of the Eskimo* by Fred Bruemmer; reprinted by permission of The Canadian Publishers, McClelland and Stewart Limited, Toronto. Macmillan Publishing Co., Inc.: Lines from poems by Robert P. Tristram Coffin—"Fireflies" and "Sunflowers" copyright 1932 by Macmillan Publishing Co., Inc., renewed 1960 by Margaret Coffin Halvosa; "The Spider" and "Cider Pressing" copyright 1929 by Macmillan Publishing Co., Inc., renewed 1957 by Robert P. Tristram Coffin, Jr.; "The Secret," copyright 1935 by Macmillan Publishing Co., Inc., renewed 1963 by Margaret Coffin Halvosa; "Oldest Airman," copyright 1945 by Macmillan Publishing Co., Inc., renewed 1965 by Margaret Coffin Halvosa, all reprinted with permission of Macmillan Publishing Co., Inc. from *Collected Poems* by Robert P. Tristram Coffin; "Indian Apples," copyright 1945 by Macmillan Publishing Co., Inc., renewed 1973 by Richard N. Coffin, Margaret Coffin Halvosa, Mary Alice Westcott, and Robert P. Tristram Coffin, Jr.; reprinted with permission of Macmillan Publishing Co., Inc., from *Poems for a Son with Wings* by Robert P. Tristram Coffin. Also "May Day" by Sara Teasdale, copyright 1920 by Macmillan Publishing Co., Inc., renewed 1948 by Mamie T. Wheless. Reprinted with permission of Macmillan Publishing Co., Inc., from *Collected Poems* by Sara Teasdale. Art and Nature Appreciation by George Opdyke, copyright 1932 by Macmillan Publishing Co., Inc., renewed 1960 by George McClure Opdyke.

Macmillan London and Baskingstoke: *The Journals of Dorothy Wordsworth* by Dorothy Wordsworth, edited by E. De Selincourt.
Norma Millay Ellis: From *Collected Poems*, Harper & Row: "Journey," copyright 1921, 1948, by Edna St. Vincent Millay and Norma Millay Ellis, and "October—An Etching," Copyright, 1934, 1962 by Edna St. Vincent Millay and Norma Millay Ellis.
W. W. Norton & Company, Inc.: *Cape Cod* by Henry David Thoreau.
Oxford University Press: *A Sand County Almanac* by Aldo Leopold; "Upon the Sight of a Beautiful Picture" by William Wordsworth from *Wordsworth's Poetical Works*, edited by E. De Selincourt and Helen Darbishire.
Penguin Books Ltd.: *Travels of Marco Polo*, translated by Ronald Latham.
The Royal Society for the Protection of Birds, Bedfordshire, England: *Birds and Green Places* by William Henry Hudson, edited by P. E. Brown and P. H. T. Hartley.
Charles Scribner's Sons: "Pasa Thalassa Thalassa" by Edward Arlington Robinson from *The Town Down the River*, copyright 1910 by Charles Scribner's Sons; "Grey" from *Selected Poems* by Oscar Williams.
Simon and Schuster: *Singing in the Morning and Other Essays about Martha's Vineyard* by Henry Beetle Hough.
Syracuse University Press: *Rural Hours* by Susan Fenimore Cooper.
Time–Life Books: Life Nature Library, *The Land and Wildlife of South America* by Marston Bates and the Editors of Time–Life Books © 1964 Time Inc.
The Viking Press, Inc.: "Tumbling Mustard," from *Blue Juniata* by Malcolm Cowley, © 1968 by Malcolm Cowley.
The Literary Trustees of Walter de la Mare and The Society of Authors as their representative: "The Listeners," from *Collected Poems* by Walter de la Mare.

CONTENTS

A Personal Note

—to all my students who made project due dates as exciting as Christmas morning;

—to Margaret Boschetti, Lyle Blair, Esther Dendel, Richard Graham, Beatrice Paolucci, and Robert Rice, who cared, in a very real way;

—to all the friends who brought me gifts of lichen, galls, madrona bark, and earth stars;

—to Mary Velthoven of The Viking Press, who commented as an editor and advised as a friend;

—to the photographers, who caught the magic, and to Lucy Wells, who typed the manuscript;

—to our children, who cheered, and to my husband, who waded in swamps and balanced on moss-upholstered cedars to fill his knapsack with my treasures;

—to the furry, feathery craftsmen who lived here first;

—to all of these, and more, I send my thanks.

Grace O. Martin

PREFACE

This book comes at a time when there is great need for it. Perhaps awe and wonder were easier to experience in simpler times when there were fewer man-made wonders about. Most man-made wonders are noisy. Quiet is difficult to achieve. It has become so foreign to many people that they are acutely uncomfortable unless some kind of noise throbs through the atmosphere they breathe. As for joy, who knows the feel of it in these hectic, empty times?

Poets know. And artists. They know agony, too, of course. But even in their travail they are intensely alive. That is something to note. Poets and artists are concerned with relationships. They want to discover what connects with what. Analogue and metaphor are the tools of their quest. The poet Marianne Moore writes, "The firs stand in a procession, each with an emerald turkey foot at the top." Once she has pointed it out, we can see it for ourselves, and perhaps we will be led to make other connections between seemingly unlike things, thus coming a little closer to realizing the underlying unity in all nature. We are pleasantly led in this quest by the wisely chosen quotes throughout this book.

Since we are, ourselves, in Nature, there is a sense of homecoming as we give complete attention to seeds and sprouts and roots, fruits and flowers, fallen leaves. There is healing in the fields and woods. Feeling starts to flow again.

I escape the pressure of clock time when I watch a bird build her nest. I marvel at the way she weaves twigs together. I offer the bird some ravels of string. How lifted up I feel when she accepts my offering and incorporates the fibers into her weaving.

The question then arises, "If I can derive so much pleasure from watching the bird weave her nest, why do I need to do anything further about it? Why should I weave? Is this not a complete experience without my turning it into a poem, a collage, a stitchery, or even a sketch?"

By watching the bird weave, I have extended myself and the responses of which I am capable. But by being merely an observer, I have not affirmed myself. I must not deny my inborn instinct to be a maker of things. Made things are not important except as the act of making brings the maker into a deeper knowledge of himself. We grow by doing. It is from these depths that joy arises, not with a thunderclap, or even a handclap, but in quiet.

<div style="text-align: right">

Esther Warner Dendel
Costa Mesa, California

</div>

7

INTRODUCTION

Fiber craftsmen today are searching for new dimensions—new ways to manipulate their yarns, ropes, fabrics, and threads to produce a statement, a soft sculpture, that is fresh and pleasing—one that may have its roots in the past but is itself a glowing symbol of today. Some do not succeed. Gallery visitors have become accustomed to viewing enormous entanglements of ropes and cables that are too often lacking in craftsmanship and aesthetic appeal. Fiber craftsmen are working in a bold, uninhibited way, and that is good. Traditional techniques of embroidery, knitting, crochet, and weaving are being worked in an exciting, unorthodox manner that no machine can be programmed to repeat. But some of these fiber creations age gracelessly—the unsupported weft sags, and the huge structures require steel armatures, pulleys, boxlike frames, and cathedral ceilings for adequate display. The tactile textile quality is lost.

Along with the movement toward great size and diversity or mixing of media, however, there is a definite surge of interest in the primitive fiber creations of prehistory. Craftsmen are haunting museums and researching such artifacts as drop spindles, vegetable fibers and dyes, back-strap looms, plaited sandals, and coiled baskets. The cultures of the Seminoles with their colorful appliqués, the nomadic Lapps with their pewter thread embroidery and finger-woven tent straps, the Yorubas in Nigeria with their indigo tie dyes and cassava starch resists, the Nootka of British Columbia with their rain capes twined of cedar bark are just a few examples of peoples and textiles that have become important to today's weavers, knotters, and stitchers. They are beginning to search the woods and fields, as early man did, to find natural constructions and habitats to use as inspiration for their own work. They are experiencing the joy a craftsman feels on completing an entirely original concept.

But many craftsmen working in textile design have lost their sense of awareness—the ability to see consciously the possibilities for design in the natural corridors through which life passes. A desire to help in developing this awareness and a desire to promote the quiet joy that comes from original thinking have been the twin stimuli that caused this book to be written.

Awareness begins at birth. Aesthetic awareness begins a few weeks later. A child's world in the cradle stage is usually soft, with yielding, gentle contours—a continuation of the safe, warm crib of the womb. A child's appreciation for the

wider world comes from painful, nose-wrinkling confrontation with roughness—in harsh contrast. The newly mown grass is sharp to pink soles that have not yet borne his weight. The dry grain of mashed potatoes is strangely foreign on his tongue. The dry, corked ridges of the butternut's bark startle his exploring hand. Slowly he becomes intimately aware of his environment and examines in detail a pill of lint on his blanket or sun dust on a shaft of light. He follows the scallopy flight of a warbler with his eyes, the zigzag course of an ant across the floor with his whole body. He is quick to stretch and to wonder.

And wonder he does through all his earliest years. The dusty trekker heading west in a creaking Conestoga from the neat town squares of New England was also aware and also wondered, but in a different sense. He had to learn roughness also—to experience the stubborn tendons of a pasture stump, the stark strength of the wedge and the adz. His interest in the warm glow of goldenrod and the curious seed follicles on a creeper was not that of the artist, the nature lover, but one of wondering: "Could I eat it?" "Could I heal with it?" "Could I coax dye or unguents from its juices?" Man and nature were so intimately connected that natural objects were something seen with only shallow understanding.

On Sunday after church in the 1890s there were small sorties out into the country to "experience" nature. These trips were documented by neatly pressed flowers in ribbon-tied booklets with a fine Spencerian script identifying each specimen. A fragile harebell became a dried and withered stalk and, as the English nature writer Richard Jefferies so succinctly put it in *The Old House at Coate*, "There is more botany in one garden buttercup than in all the shrivelled herbariums of the whole world." Victorian families, complete with nursemaids, packed wicker hampers and boarded trains to trade the city's heat for the cool of a country veranda. Every home had its planting of lilacs and tansy and feverfew. Drifts of spirea were white fountains of flowery lace "crocheted by generations of nimble-fingered New England ladies,"[1] as porch swings rocked. The designs, like the designers themselves who were held in by whalebone stays and starched-lace collars, were prim, precise, imitative. The embroideries, like the pressed flowers, were flat representational forms that echoed none of the robustness of the growing plants.

On the western frontier, the husking bee was a busy social event that left people little time to wonder at the dry whiskers of the cornsilk, the pearled rows of kernels, the layered wrapping of husks, thinner and damper with each sheath that was pulled. Man used nature, and usually wandered without wonder.

In the 1930s beauty was a leak-pocked hot-water tank cut up with a torch, mounted on legs of galvanized pipe, and filled with petunias of a baleful pink. A later development was a round flower bed circled with a tractor tire painted white. Currently technology's castoffs are being replaced by interesting rough boulders and silvery driftwood shapes more appropriate to the natural contours of a lawn.

Some young people today have tried communal living to explore the simple beauty of natural things like smiles and sheeps' wool, unglazed clay, a knotted

belt of handspun cotton. The furniture of the house becomes an oversize cushion, a bare board floor, or a leather hide supported by pegs. Living spaces are full of the scents of clover honey and cedar bark, driftwood smoke and sweet fern, home-made soap and rose-hip jelly. One is reminded of pre-literate man, whose home was a collection of four things: "a loom, a family altar, a hen's nest, and three stones for a stove."[2]

Today with our diminishing natural environment it seems appropriate to actively teach awareness, a keener, sharper seeing that will rekindle the child's wide-eyed wonder. Robert Falcon Scott, the Antarctic explorer, while near death, wrote a last letter to his wife. He is referring to their son. "Make the boy interested in natural history if you can; it is better than games." In universities there is a great surge of interest in continuous learning, to make campuses learning centers for a lifetime. On this so-small earth that Thoreau called "an incredibly precious planetary jewel," life could still be full of wonder. Richard Jefferies lived only thirty-eight years, but his journals are full of snapshots, those haunting mementos that capture and hold a mood or a moment:

> The water that runs there in the brook; the earth which I place my foot on; the air I breathe; the sunlight coming so softly through the apple bloom: these are the four miracles. . . .
>
> I tell you, as I told you before, that to-day, this hour, we are among the stars.

Jefferies lived in England long before the Wright brothers soared at Kitty Hawk. His life was short and narrow and full of silences, but in the sensitivity of his journals we find that he was, like the messenger in the *Odyssey*, "bringing a necklace of gold that with droplets of amber was beaded." Again from *The Old House at Coate*:

> When the air is utilized, too, and ships sail among the clouds, then I hope at least attention will turn to man himself. A means of locomotion to the sun yonder, shining through the apple bloom, would be wonder-ful, would yield wondrous results. But I am not looking to that. I have seen a child leap from this lichen wall, plunging into the buttercups, gathering them with shouts of joy, a glow on the face, and light in the eyes. That is what I want: more strength for the limbs; more and still more joy in living.

In the College of Human Ecology at Michigan State University, my students were concerned with the human ecosystem, the near environment. They looked at individual members of the system who are each wrapped in fiber, each design-ing living spaces, each interacting with the environment and with each other, each searching for the fuller life.

The chapters that follow illustrate an attempt to kindle an aesthetic awareness, a studied perception of the wealth of design inspiration in nature. You are en-

couraged to wander and to wonder as early man did when his observation of the heron's nest gave him the idea of thatching a roof for his own, or when his dissection of the hanging lace sleeve of the weaverbird's nest taught him about twining fibers together to make an interlacement. Textile designs, made with fabric or with threads and yarns, grow from field sketches, not from library copying or commercially packaged kits. The resulting constructions are unique. Their creation fills one with a pleasure not found by following verbatim someone else's directions.

Many quotations from poets, nature writers, philosophers, and artists have been used throughout. These are the work of craftsmen with words who have learned to see and to feel. Keats's sentence about beauty being a joy forever is a cliché now and redundant, but later lines, also from *Endymion,* have a fresh poignancy today:

> *Therefore, on every morrow, are we wreathing*
> *A flowery band to bind us to the earth*

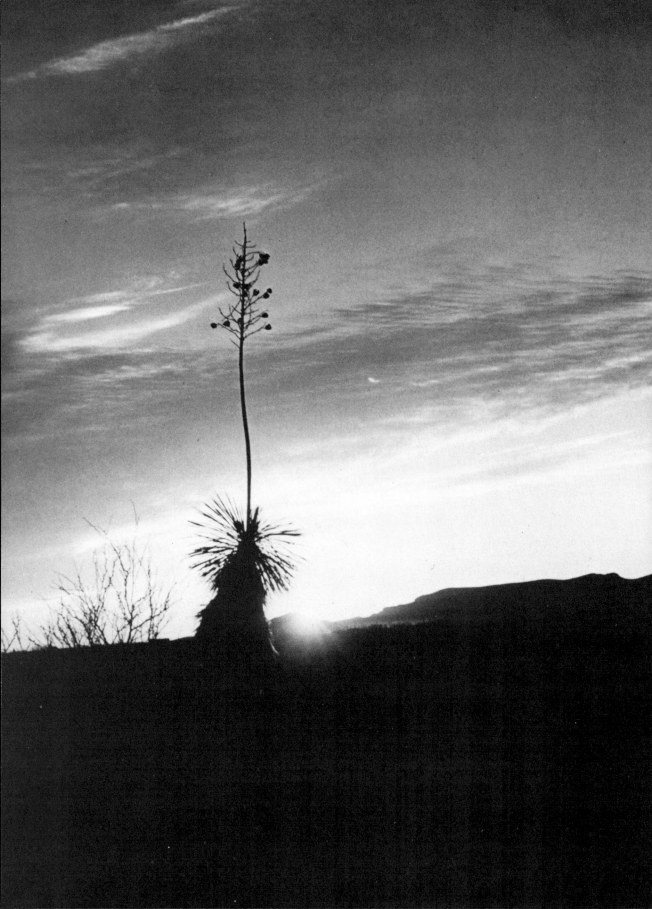

NATURAL LIGHT

The color of a southern Michigan winter is predominantly gray with only occasional and rather momentary glimpses of sky. Robert Frost in his poem "Fragmentary Blue" asks why we make so much of a flash of blue in a bird's feathers, a butterfly's wing, "When heaven presents in sheets the solid hue." In Michigan, in the winter, one is grateful for small fragments.

The grayness is of several varieties, most of them pleasant. There is the soft wet fog that fills the hollows in early morning and encloses you as though you were in a small room. It absorbs the sound of footfalls or a passing car and makes one feel wrapped in wool. Then there is a cold yellow-gray day that blots out the horizon and softens the edges of tree forms. Day has no beginning and no end that you can put your finger on. Nova Scotians call this a "weather breeder." There is an eerie, ominous feeling followed by the stark reality of a rush of wind carrying salt-sharp snow or stinging sleet.

When the sun does filter through slowly, as with a moving spotlight, and then fully, in a sudden drenching of yellow, the snowdrifts become mounds of light splinters. Dark tree trunks facing south are striped with quicksilver as the sun melts the snow cupped in the crotch. The creeks brim over and make cold mirrors out of the lowlands.

Then the gray flows in again, the temperature drops, and the evening sky is not rose or blue but a cold greened yellow like soapstone. Street lamps go on and each one is a sphere of light with a multicolored aurora that seems to go around and around. Flooding rivers creep back in their channels, leaving collars of crystal, slightly tilted, on all the dark tree trunks. At night the cold sky is alive with draperies of rose and intense green that billow and undulate in patterned splendor. Sigurd Olson, who in *Runes of the North* so sensitively paints with words the northern scene, describes the northern lights:

> . . . a vague, shimmering curtain, faintly tinged with rose and yellow, wavering across the sky. . . . Then in a sudden explosion of color the aurora returned and now there were several drifting curtains, blending and shaking and crossing one another until the entire sky was a confusion of diaphanous veils finally converging until they met in a swirling mass directly overhead.

13

Desert agave. Photograph by Frederick W. Stehr.

The seething, surging, continuous band of moving colored light with action now at center stage, now at the wings, is a Cecil B. De Mille spectacle. Its magnificence shines in John Richards' poem "Aurora Borealis," in *Songs of a Schoolmaster:*

> *As when a king reviews his thousand knights,*
> *They, horse to horse, stirrup to stirrup, stand*
> *And brandish high bright blades that catch and throw*
> *Flashes of noonday fire*

Every week after the first of the year the wands on the willow grow more and more golden until, in spring, the weeping ones are trailing chartreuse ribbons. The new leaves on the cottonwoods look as though they were formed out of patent leather or wet-look vinyl. Clear, undiluted sunlight pours down, and the clumps of marsh marigolds in the taupe swamps look freshly varnished. The air is green-yellow with expanding growth, and the light at the end of a tree-lined road is like that caused by yellow cellophane over the lens. Robert Frost observes that all the early greens are gold-colored and ends with the title of his short poem—"Nothing gold can stay." In the woods the first delicate bloom of the shadblow is a wisp of lace caught in the bare branches like a melody, long forgotten, suddenly remembered.

The greens come up and the light is hot, the yellows brassy, and the three-way bulb can't be turned up any higher. As the sun rises, shadows are sharpened and colors intensified. The noonlight shimmers and mirages float on the freeway. Under the great blue dome of a Dakota sky, in Robert Bly's words, "The grass lifts lightly in the heat/Like the ancient wing of a bird."[1] Sun-dappled lakes glint as though they had been sprinkled with broken mirrors or stitched with disks of mica, as Indian saris are. A sudden shifting of clouds, a quick withdrawal of sun, and the air is darkly purple and thickened with thunder.

The rain comes down in beads that flatten as they fall. The storm makes a dramatic entrance; there is thunderous applause, and then a fadeout in the wings as the sun returns. George Opdyke sets the scene:

> There is perhaps no more delightful sight out of doors than a drenched landscape flooded with sunlight after a thunderstorm. The reflection of the brightening sky on the myriad surfaces of every wet thing is a joy to the eye, especially in contrast to the dark, retreating form of the thundercloud. The sky is bluer than before the rain, colors everywhere are clearer, rocks glow like agates, and leaves gleam like silver and gold.[2]

Yellow sweet clover has bloomed and gone, leaving thin, browning plants in the dry soil. Suddenly all the suns of summer are mirrored in the sweep of goldenrod up the hills. In *A Week on the Concord and Merrimack Rivers* Thoreau made note of this golden time:

> It is the floral solstice a little after midsummer, when the particles of golden light, the sun-dust, have, as it were, fallen like seeds on the earth, and produced these blossoms.

14

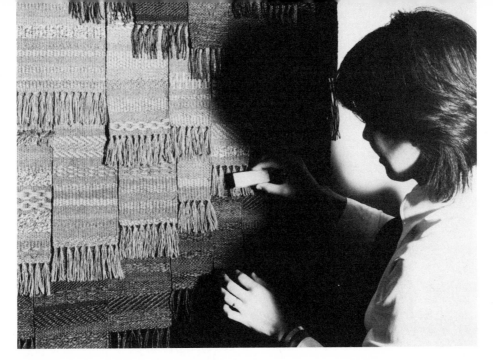

Reiko Hirosawa combs the warp ends of the glowing multi-tapestry shown in Color Plate 3. She spun, plied, and dyed some of the weft yarns herself to obtain the needed shadings.

Warm summer nights are filled with moving light points that blink off and on in the cool grass, and children collect the glowing "tinker belles" in cupped hands and bottles, capturing the magic light of Robert P. Tristram Coffin's poem "Fireflies":

> *Earth is too hot and sweet to sleep tonight,*
> *She feels electric fingers brush her hair;*
> *Ten million candles with their sudden light*
> *Are going up and down the wedding stair.*

As the growth cycle slows, sumac burns red torches on the hills, and the pool of light under the maples is flame-red and hot. The sky is a scrubbed-clean blue, but the soft gray fogs flow into the low places again, coating plums and raspberry canes with a blue-purple bloom. The sunshine in October is liquid amber, and it mesmerizes. A spiderling leaves home by climbing to the tip of a twig or a blade of grass, where it exudes a silky filament and rides off on a current of air, climbing to the center of its silver strand to soar. Scientists call this aerial nest-leaving "ballooning," and the spiderlings' silver threads float in the air on a warm day in late summer and brush fleetingly against the face. The air is drowsy and filled with floating things. The swollen pods on the milkweed pale and dry until one day the furred gray oval slowly splits, releasing feathered chutes that float—and fly. Mourning doves coo in monosyllables, and students drowsing on sun-warm slopes keep remembering Matthew Arnold's question in "Empedocles on Etna," "Is it so small a thing/to have enjoy'd the sun?"

15

Three-dimensional sun needle-woven on a cardboard circle by Sandra Ridella. The long streamers were separately loom-woven and the wrapped rays tasseled with turkey feathers.

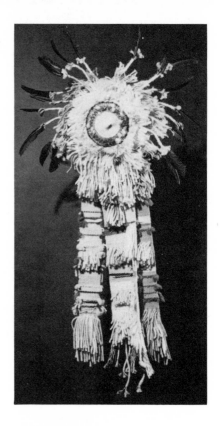

Winter sunrise framed by tree branches in an appliquéd hanging by Julie Morang.

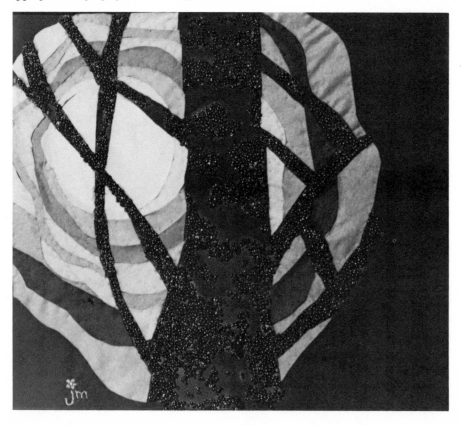

Dawn light in a mandala of indigo-dyed yarns finger-woven on a linen warp by Susan Michalski Parent.

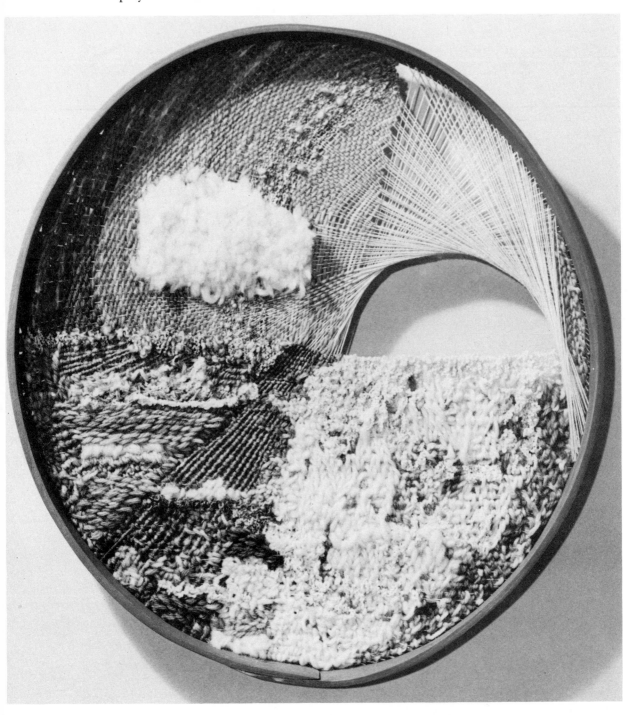

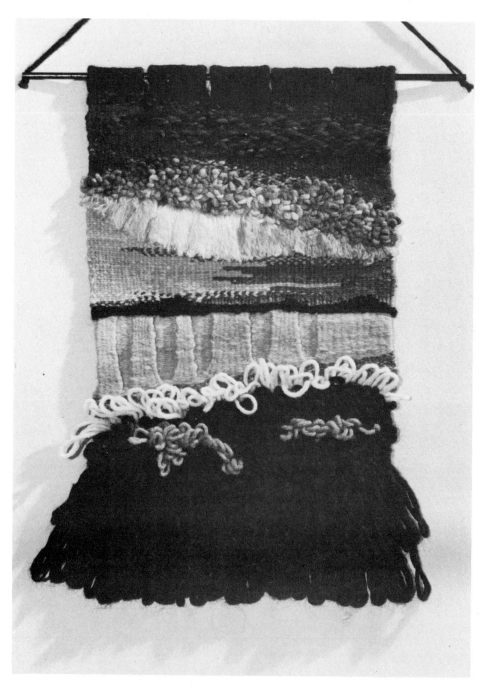

Dawn comes up reluctantly in December. Double-woven
hanging in nature-dyed yarns by Mary Lynne Richards.

The Light Touch

An Experience in Stitchery

1. Windows are peepholes. When you look out of yours, what do you see? Perhaps it is the top of a car, a maple tree, the chimney of a neighbor's house, an ancient lilac bush, or a field of soybeans—a pattern of wide-wale corduroy flowing over a hill. Decide which window view or which part of it interests you most and then set the alarm for daybreak.

2. Look at the same scene again, slowly now, and carefully. Let your eyes travel over it, inch by inch. See the sharp edges of the lighted forms yellowed by the sun. If it is a gray day with no sun showing and all the surfaces are high and low values of gray, look for a slight thinning of the gray as early light streaks the sky and whitens the eastern edges. If it is raining, look for silvery contours on the east facing surfaces. Jot down a few notes or try to remember what you see.

3. In the evening, when the warm sky light is cooling fast and the sun is very low in the sky, look out the same window again. Search out the blue-purple shadows that now mask the bright edges of morning.

4. In a sewing box or knitting bag, look for yarns and threads and begin to assemble two groups of them—one to give the dawn-light experience, and one to give the feeling of the long-shadow part of the day. If you are looking at a brick wall, for instance, carefully observe how the sunset color changes from the orangy brown of morning to one that is dulled by evening to a brown with blue overtones like slate. Hunt for shiny or mercerized threads that have been polished, or rayon or silk ones that are inherently glossy and reflect the light. Hunt for textured yarns, such as mohair and wool, and shaggy linens—thin ones, soft ones, round ones, flat ones, yarns loopy as a raveled sweater.

5. Find a piece of stiff cardboard—the bottom of a writing pad or the cover of a shoe box or the cardboard circle a birthday cake sat on. Cut notches at even intervals all around the circle or on two opposing edges of a square or a rectangle.

6. Using one of your yarns or cords, wrap it over the cardboard, anchoring each turn around a notch in the cardboard edge.

7. Then with your fingers or a blunt needle with a large eye, start darning in selected threads over and under and over and under, pushing them into place with the point of the needle, the teeth of a comb, or the tines of a fork. On one side of the paper loom weave a statement about the morning time of the day and on the other side a fiber sketch that suggests the cooler tones of evening light. Play with texture. Bring out the character of a shaggy yarn by framing it with smoother and finer ones. Dramatize a green thread by startling it with red.

8. When all the foundation cords or warp yarns have been woven or covered with the filling yarns on both sides of the cardboard, slip the thread loops off the notches. You will hold a double-woven fabric that is a statement about dawn and sunset light—in yarn.

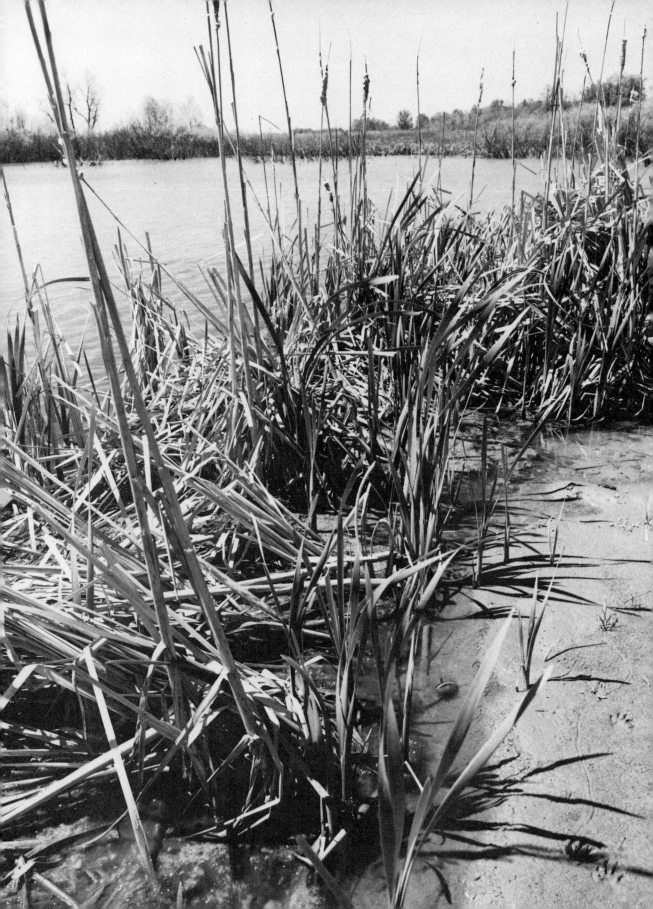

THE ORIGINAL OUTDOOR CARPET

The sharp-edged wind rustles the stiff taffeta frocks of October corn. Small suns of helianthus glow in the fence rows, and the dry dusts of autumn gray the golds and make bronze out of brass. Frost-crisped leaves collect noisily in the hollows and with a gusty whirlpool move on. Listen, with Robert Bly, "And hear the corn leaves scrape their feet on the wind."[1] Windfalls in the orchard pave the grass with red cobblestones, smelling faintly of cider, and yellow jackets star the fruity floor with noisy yellow. Ploughed fields are corduroy stripes of black and tan, with the barley stubble rows sharp and dry and dusty and the turned furrows soft and darkly steaming.

The pasture, once aglow with goldenrod, has cooled, and Saint-John's-wort stains hands with purple, hinting of cooler hues to follow. Now there are aster clumps marking the hour with violet stars, "And my lonely spirit thrills/To see the frosty asters like a smoke upon the hills."[2] The blue purple disappears with lowering skies, and rose hips fade with freezing—the orchard carpet becomes brown as apple butter. The land is a study in sepia ink done with quick hard strokes of a pen, sharp and sere.

The first snow fills the low places with soft white, and islands of dry browned grass and matted leaves rise on the crowns. Longfellow, in "Snow Flakes," has a beautiful description of what follows:

> *Over the woodlands brown and bare,*
> *Over the harvest-fields forsaken,*
> *Silent, and soft, and slow*
> *Descends the snow.*

Now the world is white, shadows are blue. Queen Anne's lace waves a dry wand here and there, and raspberry canes make red arches against the sky. The year ends and the hillside is a tangled layered mat of long grasses and snow, like jack straws fallen in a heap. Small dark holes in the drifts show that field mice have gone underground.

The rising sun wears pockets in the snow along the fence ridges, and through the Swiss-cheese openings last year's cinquefoil pushes up like scarecrow straw. The gray-green whorl of mullein leaves shows its woolly ears. This first grayed green of beginning life has been alive all winter under the snow. The Indians made a mullein tea and a singing yellow dye out of the cottoned petals, fur-coated against

21

A warm/cold, wet/dry carpet of bleached grass and sky-colored water. Photograph by Dick Wesley.

the winter, ". . . and mullein candles/With leaves a man finds woolen when he handles."[3]

With strengthening sun, the lengthening winter wheat raises a clipped green pile, visibly longer day by day. In the woods thick-carpeted trout lilies push up brown-spotted leaves, and in the yards lily-of-the-valley beds become a mat of slender green pencils, pointed end up. Paper-white triangles mark the trillium beds on "the forest's ferny floor"[4] and as Sara Teasdale wrote exultingly in "May Day," "The smell of wet, wild earth/Is everywhere."

Soft warm rain makes sodden sponges of the moss, and the earth yields to the farmer's boots. Near the spring, where cattle have raised hummocks of earth, the ground is upholstered in green velveteen and overprinted with anemones and clover. In the north woods, lovers walk in whisper-broken silences "Where pine and moss lay velvet floors and a wanderer walks like a king."[5]

Botanists call the earth's floor "Canadian carpet" in the northern sections of the continent, where growth is unhurried and untrampled. In *Journeys in Green Places* Virginia Eifert tells what it is like:

> The name *Canadian carpet* serves to explain this cool, fragrant, north-woods upholstery which covers the ground and old stumps and logs with a delicious, compact, often wintergreen-flavored growth of evergreen leaves on low plants and vines.

This was an all-green carpet with pile of several different heights and textures. Now read Virginia Eifert's description of this jewel-toned flossa:

> . . . a splendid array of carpeting richer than any Oriental rug, orna-mented with orchids and colored sea-blue with dwarf irises, purple-rose with gaywings, scarlet and gold with paintbrush, and glorious deep green with compact, evergreen leaves.

In the cool remoteness of northern British Columbia there is another colorful carpet that few have seen, that of Theodora Stanwell-Fletcher's *Driftwood Valley:*

> No forests have such lovely floors as these northern ones. Scarlet bunch-berry is scattered everywhere over deep green moss—moss so thick it feels as though one were walking on pillows. There are masses of oak and lady ferns, Lycopodiums, trailing Linnaea, blue-berried Clintonia.

At dawn and dusk the rains and warming earth bring the gray chiffon of mist that Thoreau described as a "low-anchored cloud" or again as a "drifting meadow of the air." Now the outdoor carpet is a vibrant green—emerald, chartreuse, olive, and veridian—verdant, pulsing, growing, and buttoned down with gold—and the weeds grow tall.

Glints of sun on the shady carpet of a woodlot. Vivian Hoxsey extracted shades from beige to copper by applying bleach to black satin lining material.

The blossoming desert floor in hot pink and rose, woven of shaggy linen, soft wools, and velvet and grosgrain ribbons by Sharla Jean Hoskin.

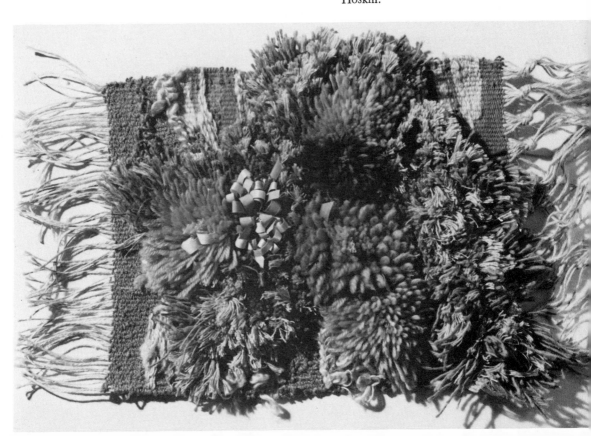

A tree branch molded by the sea into a fish-like form holds a hanging woven by Leah B. Hoopfer that suggests the textures of the beach.

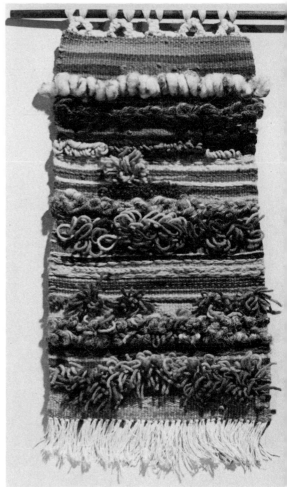

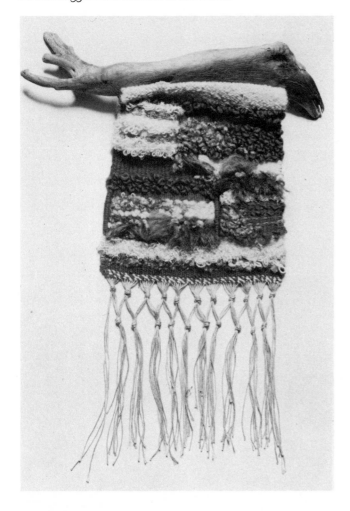

Nature makes random clumps and ridges; man makes furrows among them. A landscape in nature's colors by Dianne Olrich Offer.

A glimpse of the sea captured in indigo and
onion-dyed wools by Susan Jones.

The Braille Trail

Experiments with Texture

To touch is to know. In this exercise we are going to examine and study and feel textures just as a blind person does when orienting himself to a new environment. Anyone can "see" texture better or more sensitively with eyes closed. In Colorado, at Aspen, the Forest Service has set up a nature trail specifically for the sightless. Here children and adults can feel the scaled bark of an Engelmann spruce, walk on a pine carpet, feel the marks of beaver teeth on an aspen, hear the fast-running stream.

1. Remove your shoes. Walk slowly around your personal living space with eyes closed. Feel and remember the differences between the smooth tile or the textured wood or the bath mat, soft as the new grass of spring.

2. Find a riverbank or a pasture stream or a reedy hollow and once again remove your boots and slowly, with eyes shut, explore and remember the textures you find underfoot. Temperature becomes important; damp sand or cool clay beside a stream will feel completely different from an August dune or a dried-up stream bed where clay is curled up like shakes on a weathered cabin roof.

If it is too cold to go barefoot, take off your gloves and run your hands over the frost-fragile grasses—the short, dense pile of a lawn and the sparse blades along the walk that have been formed into croquet arches by freezing rain.

3. Using a soft drawing pencil (such as #HB 3 or 4) and a vellum pad or white shelf paper, make a design by filling the page with areas of gray. With just one pencil you can shade light, medium, dark, and very dark. With different strokes you can make some of the separate areas more interesting—smooth strokes like smooth stones or pencil squiggles like gravel underfoot. Your composition will be more successful if it has one area that is more interesting than another. This might be the lightest or the darkest part so the contrast in values makes it stand out. It could also be an area that is rougher or smoother or larger or smaller than the other parts of the design.

4. Find a piece of rug canvas or upholsterer's burlap at least a foot square. Upholsterer's burlap has twice as many threads per inch as ordinary burlap. It is used by furniture makers because it does not stretch or sag or pull out of shape and can recover its form after holes have been punched in it. Stretch this fabric firmly over a wooden frame or stretcher; a rug-hooking frame or a large hoop used for quilting may serve as a ready-made stretcher.

5. Now you need to go on a yarn-collecting expedition. Look for whites, grays, charcoals, and blacks—the undyed yarns. Because we are feeling texture, not just looking at it, we do not want to complicate the problem by using additive color. Search in knitting shops, needlepoint and crewel boutiques; hunt in shallow drawer cabinets for embroidery floss, satin ribbon on round spools, velvet ribbon on oval spools, mat-finish grosgrain in folded hanks. Look for mop heads and suede boot laces, ready-cut rug yarns, raffia, and straw.

6. With your soft pencil lightly transfer the main lines of the composition that you sketched on paper to the stretched fabric. Then, using a few feet of each yarn or thread or ribbon, roll it up loosely and place it on the spot where you think it belongs, either because of its texture or its size or its mood. Move the yarn, thread, or ribbon around until the arrangement pleases. Now the problem is to cover the background fabric completely with the yarns chosen.

7. To transfer the loose yarns to a permanent place on the backing, you could use any or all of the following:

 a. a crochet hook (medium) c. a rug punch
 b. a large-eye needle d. a rug hook (latchet hook)

The crochet hook can be used to pierce the cloth and bring up to the surface loops of yarn or yarns held underneath. Loops can be crowded together, or random in size, or formed of several fine threads or yarns used as one. The large-eye needle can be used to cover a section of the backing with a solid mass of chain stitching or herringbone or to make a pile stitch with a needle as canvas embroiderers do. The rug punch allows you to make loops continuously from a single ball of yarn. If you have never used a punch, ask for a demonstration before you buy one. It's amazingly easy to use. Try changing direction as you punch to make ridges, or try going around and around in concentric rings. Most punches have an adjustment that allows the user to make both low and high loops, so you can create several textures with this one tool. Remember to work on the wrong side of the cloth.

The rug hook is usually called the latchet hook because a small metal strip attached to the hook knots the yarn as the tool is removed. This is the same Ghiordes-type rug knot that has been used in Persian carpets for generations. The loops formed by a rug punch pull out easily (unless they are painted with latex on the reverse side) but the knots formed by the latchet hook are there until you take them out. Try ready-cut rug yarns to make a shaggy pile. Try using between six and ten fine yarns together as one to make soft shading. Try pieces of ribbon or raffia or narrow strips of capeskin or suede. When all the areas of your natural carpet have been filled, take one or two of the high-pile areas and with scissors or a razor blade shorten some of the knots to make a dense, low pile similar to the green plush of moss. Now take a stiff vegetable brush or a hairbrush or a toothbrush and go over and over a rug knot area, as though you were stroking a kitten while reading, until the yarns all fray out like spun silk.

Once in October in a good milkweed year, on a wandering country road, I came to a spot where children had literally covered the lane with its white silk parachutes—a fine light texture on which you could make an imprint of your passing.

NATURAL LINE

Infinite, Finite, Concentric

The horizon taut as a gleaming line.[1]

There are myriad lines in nature—long, trailing ones that seem to be infinite in length, shorter finite ones, and those that curve into spirals or enclose each other, concentrically. Some of them, however, illustrate all three characteristics.

Perhaps the longest lines are the delicate silk ones exuded by spiders and some of the moths. The chrysalis of a cecropia, for instance, may contain six hundred yards of cocoon silk in one unbroken filament. Another insect group, the beetles, burrow under the bark of logs to form meandering mazelike trails that go on for yards and yards. But many of the plants and weeds grow long lines, propagating with runners, sending out long umbilical cords to bind a new embryonic plant to earth. In October "Strawberries lace the valley floor with red runners"[2] and the white silk disks of the convolvulus polka-dot the dusty roadsides and climb up dry, clay-colored road cuts with the gravel rolling out. They grow almost anywhere, even on barren, acrid ground, the size of their blooms depending on the moisture available to them. They climb up and down any weeds in their path, binding them together and making a tough, fibrous snood to hold the soil in place. Another ground cover, not accidental but planned and planted, is formed of the mounds of purple and red-violet crown vetch that make highway crossings and rail embankments in Iowa into lumpy carpets hooked of heather. In winter their bare bones become coarse brown net, trapping and holding the snow.

In many places in wasteland one finds fibrous scribblings crossing and recrossing one another until the lines, like doodling on a telephone pad, have no apparent end. In the dry sands of a Maine beach the "silvery cinquefoil sends out long, rooting runners which hold the sand in place."[3] In moist places where partial shade conserves the damp, the growth is luxuriant and never-ending. See these green places as Virginia Eifert does:

> The snowberry tapestry is one of the most effective upholsterings of old rotting logs and tree roots in swamps. It is a petit-point creation of miniature leaves on tiny, intertwining vines. . . . the wiry, trailing stems overlap and interweave and thickly conceal surfaces needing a year-round cover.

Tall poplars become lashed in place with ancient inch-thick bittersweet vines like cables spiraling the trunk and culminating in a mass of thin leaves that in the

29

Natural lines upholstered with snow. Photograph by Dick Wesley.

fall turn yellow-green—like chartreuse tissue backlighted by the sun. With the first frost the covering on the orange fruit splits, disclosing the flame-red sphere holding the seed.

These vines are round and smooth like polished linen cord, but the vines of the wild grape are shaggy ropes of jute or sisal, tough and cocoa-brown, that hang in great loops like telephone cables toppled by a storm. Strong enough for a man to swing on, they often hold up the bleaching skeleton of a tree or build an umbrella-shaped canopy over a smaller one. The fruit hangs in small dusty-blue pendants with tendrils forming corkscrew curls at either side.

In the northern woods in May the fragrance of the trailing arbutus hangs in the air like a pink mist, and one can zero in on a patch by following the scent. At first glance the leaves appear like smooth leather ones standing on end, as though they were being rooted in sand in a hothouse. Kneeling to exclaim at the pink-and-white perfection of the blossoms, one can see the long lines of reaching runners on top of or just below the woodland floor. A close neighbor might be the evergreen creeper, running pine, or the yellow-green shag carpet of one of the Lycopodium, its evergreen upright fingers round as Christmas tree garlands, its gold-colored seed stalks a candelabra for a doll's house.

There are two other growing lines of infinite length that should be mentioned here. The long trailers of the virgin's bower light the August roadsides with shiny threads of white silk gleaming like glass—"like a vine clinging in the sunlight, and like water descending in the dark.[4] These tufts of silk are ragged whorls that soon lose their virginity and become dull tangles of off-white cottony fluff that hang on all winter.

The wild cucumber turns trees and shrubs in damp places into green mounds and rounds them into clumps by covering them completely with green garlands trimmed with a white lace edging—small flowers standing up on short stems. It is an eerie moonscape with only dark cave mouths to mark the place where the forks of the branches were. In winter these vines are thin toast-colored festoons. Here and there hang the small melons of the hollow, fibrous seed pods, weightless in the wind.

There are other long lines to consider. Some of them are branches that appear longer than they are because they are slender and drooping and hang like long loose threads in winter and long green hair in spring. The contemporary nature poet Wendell Berry, in his poem "The Heron," sees other strands.

> *I go easy and silent, and the warblers*
> *appear among the leaves of the willows,*
> *their flight like gold thread*
> *quick in the live tapestry of the leaves.*

Finite lines in nature are found in many lengths. There are the quarter-inch gold hairs of asparagus fern that dust the shoulders of small boys building a hide-out in a patch of it. The slightly longer needles of the tamarack look evergreen, but in October they, too, turn yellow and drop. In A *Sand County Almanac* Aldo

Leopold observes their fate: "Under each the needles of yesterday fall to earth building a blanket of smoky gold; at the tip of each the bud of tomorrow, preformed, poised, awaits another spring."

There are the six-inch pink stems of Virginia creeper that stand out like spines on a vine-covered church after the leaves come down. One day they are there and the next they may be floating in a puddle of cold October rain. Seed pods dangle from the catalpas. Like the trees' coarse leaves, they are large and showy and a strange sequel to the miniature orchids of its bloom. The green rods gradually brown, and eventually the winter storms rattle them loose and they crosshatch the snow, randomly.

The honey locusts drop their miniature leaves first, and they crunch underfoot like dry cereal spilled on the kitchen floor. Later all the leaf stems fall, thin arching wires that slip through a rake. The young ailanthus trees, too, drop all their branches and stand as a stark vertical pole, rounded at the end as the wooden handle of a hoe.

There are many short natural lines that are not really finite but rooted in the earth, some of them standing in shallow water. In the marshes we hear "waving their pennants in the wind the dry rustling of the sedges"[5] whose leaves hang in shreds of ribbon streamers and whose tops are tufts of brown cotton on umbrella-rib stems. There are all the grasses and reeds and the sedges and the weeds, the hairline stems of the harebell, and the columbine. The latter appears to hover in the air like a bird, its stem almost invisible under the bicolored silk of the flower. Early settlers in Colorado called it a dove.

Goethe described grass as "the living garment of God," and many writers have penned phrases describing its strength and its beauty. In John Ruskin's "Of Leaf Beauty" in *Modern Painters* are many images:

> minute, granular, feathery, or downy seed-vessels, mingling quaint brown punctuation, and dusty tremors of dancing grain, with the bloom of the nearer fields; and casting a gossamered grayness and softness of plumy mist along their surfaces far away. . . .

In "October—An Etching" Edna St. Vincent Millay described this as a time when "Tussocks of faded grass are islands in the pasture swamp"—and in "On the Hill Late at Night" Wendell Berry writes:

> *The ripe grassheads bend in the starlight*
> *in the soft wind, . . .*

In April lengthening days and warming sun trigger new growth, and unfolding leaves and searching stems fill up the winter spaces. Virginia Eifert finds:

> In spring I am surrounded by the pattern of shadows made by the wormwood lace, the embroidery of the cinquefoil, and the stark, inked, fence-shadows of the rushes; . . .

The age of the giant redwoods and the antique bristlecone pine have been

Freehand painting with formaldehyde bleach on rayon lining fabric by Robin Curiak.

determined by counting the concentric growth rings that, wide or narrow, dark or light, record the years of their existence. Artists have long known of their many possibilities for pattern design. But there are other curved-lines-on-curved-lines that excite the imagination. There are the undulating stripe patterns of wind-eroded sandstone and similar patterns in water-eroded limestone. The sun glints on quartz veins layered in a granite boulder. These curving lines are enormous. Think small and discover the more subtle curves closer at hand. The sweet fern whose woody stems and fragrant leather-like leaves perfume the north woods in late fall curls these small scalloped strips into lacy brown spheres—crisp paper lanterns at the ends of the stalks. Queen Anne's lace turns its umbrellas inside out, fireweed seed pods become slender rings with silvery linings, and on the top of a wind-combed dune in Sand County "Every wisp of grass is drawing circles on the sand."

As the growing year ends and ground cherry lanterns become light as balsa, the branching stems of pigweed and Russian thistle curve upward, enclosing each other to form a transparent globe. A sharp gust of wind severs the taproot and they roll across the open prairie singly or in groups, like children let out of school, unexpectedly. When the wind drops, they stockpile themselves against a fence or a wolf willow. They are beautiful natural spheres that become rounder as they roll.

Tumbleweed, tumbleweed,
riding his velocipede . . .[6]

32

Diane Augustine used a laundry marker for details
on this freehand painting done with laundry bleach.

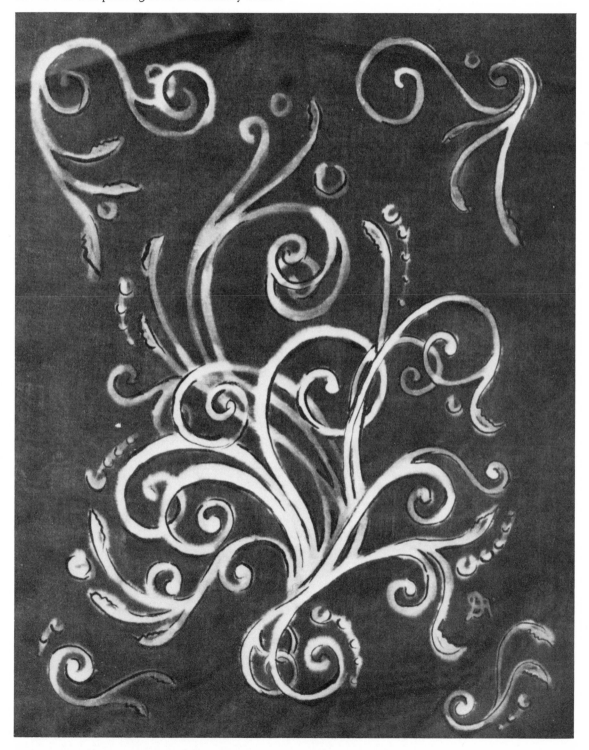

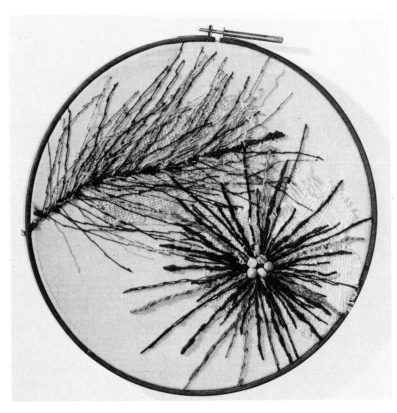

A cluster of pine needles. Linen appliqué and couching by Roberta Martin.

The delicacy of insect webs inspired this composite loom of silk, linen, and alpaca by Gayle Ott Reed.

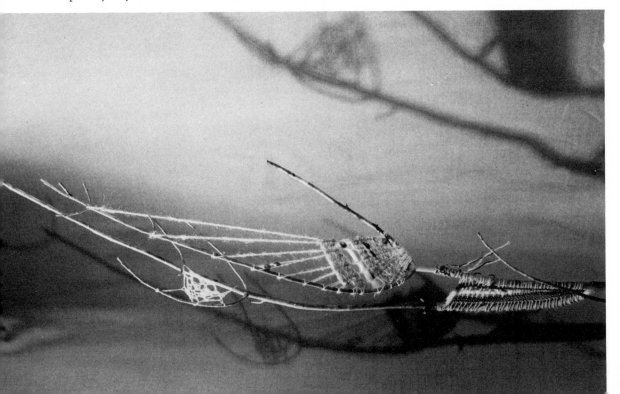

Warm earth tones and cool sky colors in an oval of linen threads and nature-dyed yarns intertwined using the techniques of sprang and needle-weaving, by Alan M. Huston.

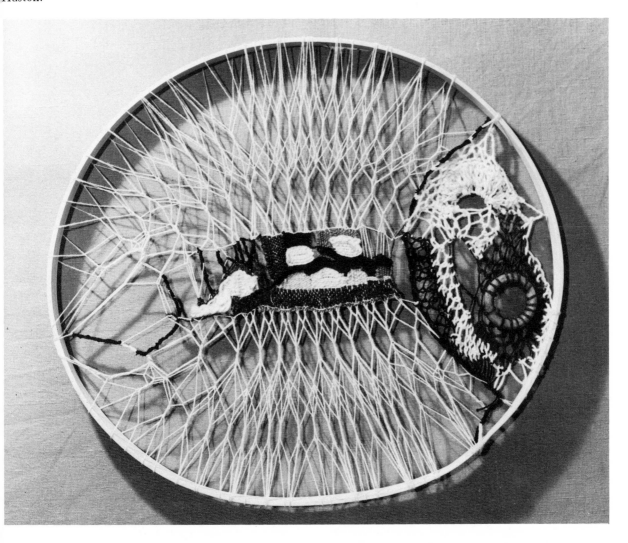

An ivy-wrapped birch suggested these natural growth lines of silk and rayon to Pamela Plummer.

Hard and soft lines of yarn woven through the rigidities of bone marrow by Rosemary Loiacano.

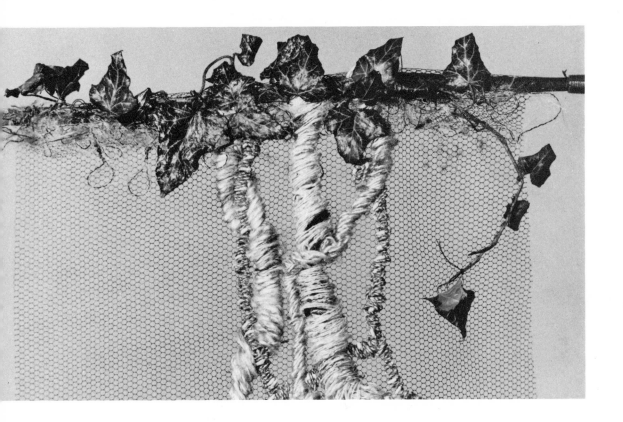

Meandering

Adventures in Couching and Darning

While we wait, we doodle. Intricate designs grow like crystal gardens in the margins of phone books, on the backs of old letters. Some, done by famous people, are rescued from wastebaskets and hung in museums. But usually they are designed only to fill a passing moment, an empty space. The most common is a continuous line with one beginning and one ending. Doodling is a creative way to play with patterning. If we design consciously, we usually try to make a focal point or a center of interest in the composition. When we are working with a fluid line, there are several ways to achieve this:

 a. The line may change direction, abruptly or gradually.
 b. It may change in diameter, get suddenly thinner or broader.
 c. There may be a concentration of line in one spot—a shrinking of the space between the lines.
 d. There may be an absence of line, a void, surrounded by line happenings.
 e. The center of interest may be circled or underlined or pointed to by the lines.

Experiment with the things at hand:

1. Pull off a piece of bark from a fallen tree or a log from the fireplace. Look for the pattern of incised lines chewed out of the wood pulp by bark beetles—small tunnels that go on and on, over and under, and back and forth with no apparent end in sight.

A walk on your lawn, a golf course, or any other place where there is sod might reveal mole tunnels—corded mazes that go on and on, around and through.

2. There are two ways to create a yarn or thread doodle with an infinite line drawn as though the artist never lifted pen from paper. The first of these is called couching. The background fabric is pressed and stretched and then the ball of yarn is slowly unwound over the cloth, moving in lines or squares or undulating ovals or whatever, but it goes on and on until the space is filled. Wool yarn, with its natural roughness, will stay where you put it on the fabric, but it can be easily changed or moved or amended until the designer is pleased. When selecting materials to use, think about nature's continuous lines—the ancient grapevine, thick as a wrist and strong enough for a suspension bridge over a stream. The finer, smoother cables of bittersweet that are strong enough to hold upright the skeleton of a long-dead elm. The red runners of strawberries that connect anchored plants and are tough enough to trip a man—or the airy tents the webworm builds, delicate enough to cradle a petal.

3. To attach the line to the backing, we use auxiliary stitches to hold the line in place at intervals along its length. The line itself does not penetrate the cloth at all but lies on the surface and is held down with small stitches tacking it in place. These holding stitches, called couching, can also be made decorative by using another color or another stitch, such as a simple cross-stitch, as the binder —just as a purple vetch uses a corkscrew tendril to hang on to clover.

A new telephone pole will often show beetle tunnels trailing up, over, and around the pole—wood tone on wood tone. A field mouse or the thumb-size shrew raises a pattern of meandering white cording while tunneling under new snow. Take a tip from the beetle or the shrew and use self-color—yarn or cord that matches the background fabric. The raised and rounded cords or yarns will cast shadows that will be accent enough.

4. Another way to create a continuous line design with fibers is to darn it into an open-weave fabric, making a delicate transparency like that of gauze or nainsook. Buy a piece of black nylon net. It is strong and it is cheap. Because it comes 72″ wide, you will need very little. Iron the creases out with a damp cloth and a cool iron before beginning to darn. Now cut a mat (a paper frame) out of poster board or the side of a corrugated box and attach the net to the frame with masking tape.

5. In darning you should select only those yarns that can be pulled through the holes in the net without tearing the black threads and only those fibers that can be pulled through the needle.

Using a two-yard length of yarn in the needle, start darning it into the holes of the net. Remember the decorative line is only being laced through the

holes, not really piercing the net fabric itself. When the thread is all used up, simply cut off the tag end and begin again. Sewing thread used double in the needle is very good, and because there is such a wealth of choice in colors, some very subtle blending can be done.

Be careful to consider the ends of the lines. A cut end is not natural. Vines curve up on the ends or cross over one another, but they don't just stop abruptly. Keep working along, building up the design as it happens. If this scares you, do a paper doodle first and use it as a map to follow. The fun is that any unwanted line can simply be pulled out and the design amended.

6. Because the couched design is opaque and the darned design is transparent, there are obvious differences, but they are both line designs whether finite or infinite or concentric. Both of them can sometimes be enhanced by the addition of three-dimensional objects to heighten interest, just as in nature one might find an empty acorn cup or the discarded lace of a mayfly's wing. Small clay or wooden beads might be appropriate for the couching sampler, but for the transparency it may be better to add tiny clear or opalescent ones that could be threaded on the line like rain baubles on a web.

7. The couched design must remain stretched and taut and can stay on the frame on which it was worked. If desired, wooden picture molding or lath can be used to frame the edges. If you have worked in self-color, such as white on white or brown on brown, perhaps it would be well to paint the frame the same color.

The transparency, however, is best viewed with light coming through. It can be used as a flexible wall hanging with clear lucite rods at top and bottom, or it can be stretched and sandwiched between two matching frames that are not too heavy. An alternate method would be to glue the fabric ends to a piece of half-round wooden molding, stained black, and then to face this piece with a matching one. This not only adds weight but camouflages the ends of the net as well.

When you are working on this experiment, think about lines. Doodle a lot. Remember the broken line formed by the tracks of a winter rabbit out looking for his lunch, or the fine soft strokes of nimbus clouds covering half an August sky.

The harvest of summer held in the deep-
freeze of winter. Photograph by Dick Wesley.

NATURAL CLUSTERS, AS FOUND IN WINTER

The year goes out in a gold and scarlet blaze. Goldenrod plumes that Henry Beetle Hough described as "the measuring stick of summer" and again as "the treasure that lies at the end of summer" flare up and fade on the pasture slopes. The greens brown and the sky cools. When autumn winds pull the leaves down and branches are seen in silhouette, the linear quality of the tree and negative spaces formed between the branches become very apparent. The obvious showy color of goldenrod and asters is gone; sentimentality is gone. What remains is the basic beauty of line, shape, and form—black, brown, and white and all the subtle nuances between. Beauty not flamboyant now but beauty to be searched out and found. Loren Eiseley wrote of it in *The Immense Journey*:

> In autumn one is not confused by activity and green leaves. . . . There is an unparalleled opportunity to examine in sharp and beautiful angularity the shape of life without its disturbing muddle of juices and leaves.

The lines formed by grasses grown sere are short and straight by the walk, long and graceful by the streams, and head down in the ploughed furrows. Snow-weighted brambles arch to the ground, and love grass raises frost-crisped aerials that snap in the wind. Lines become important. Eiseley speaks about a time he roamed the winter-locked Platte River country:

> The rivulets were frozen, and over the marshlands the willow thickets made such an array of vertical lines against the snow that tramping through them produced strange optical illusions and dizziness.

A beautiful twisted line against the pewter sky is a gnarled old apple tree with the globes of golden Delicious apples like amber mobiles turning in the wind. These solitary trees, probably planted by birds long ago, have had to struggle to live. Shaped by storms, wrapped by wild grape and the remnants of a fence, they flaunt the golden spheres long after the golden leaves have been frozen to the ground. Robert P. Tristram Coffin describes them in his poem "Indian Apples":

> *Tough as old iron, twisted in bitter grain,*
> *They have learned from briars to run to thorns,*
> *They hide the whippoorwills when they complain,*
> *Under them the shy deer casts his horns.*

41

Thinking about clusters or groups of lines as seen in the winter landscape, it would be well to consider several related words and their meanings. Besides "clusters" and "groups" there are also words like "clumps" and "clones." Webster describes a cluster as a number of things of the same kind (as fruit or flowers) growing closely together; a number of similar things grouped together in association or in physical proximity, or as a number of similar things considered as a group because of their relation to each other. His categories for a clump are a group of things clustered together, or a compact mass, a closely compact group. To the botanist a clone is an aggregate of the progeny of an individual plant.

A winter walk will reveal many clusters of lines, shapes, and textures to serve as inspiration for design. The landscape may appear spare and stark, but Hough, defending bleakness, says that

> . . . bleakness has beauties of appearance and sensation in its own right; it brings out subtle harmonies of landscape and tingling realizations in the dweller among bleak things.

When the earth and the tree branches are upholstered in snow, the lines are softened and the landscape becomes a study in contrasts—black and white, dark and light, hard and soft. Individual textural differences in bark become very apparent. The shagbark hickory with its rough look of curled-up shingles contrasts sharply with the smooth, tight, stainy bark of the chokecherry and the gray-white scaling patches of the sycamore.

There are groups of ridges in the corrugated bark of elm, some of them embroidered with green chenille to make mossy accents in the hollows. Whorls of gray-green lichen crown the knobby limbs of poplar, and small clumps of granular gold lichens button down the streaked bark. A clone of oyster-like shelf fungus decorates the dark damp of an old stump, and checking lines radiate from the center. Here a squirrel has left a cluster of "cornflakes" where he breakfasted on pine nuts by pulling the cone apart, petal by petal. Clusters and clumps and groups of lines and textured shapes are everywhere.

There are great differences to be found in bark, grasses, and growth lines, but snow, too, has wide textural variables—soft and grainy, hard and sleek as butterscotch or indented to a lace-like filigree where the edge of a drift erodes in the sun. Clusters of crystal icicles where warm sun made the snow molten, and it dripped. Frost lace on the morning windows makes patterns of rare beauty, and winter wind carves ridged designs in the snow dune beside the barn. A warming sun burns pockmarks in a drift the way a dripping ceiling in a cave wears holes in limestock rock. Snow frosting, balanced precariously on a sun-warmed branch, slips and lets go, falling with a soft thud, and suggests an incised pattern for a white rug with high-and-low-clipped pile in natural wool.

Winter grays with age, and the sky and the earth are a monotone, the cadence slowed. A day of warming sun, and Nature washes her hands of winter; dirty water gurgles down the drain, leaving only spots of suds on the frozen grass.

There are highlights of white, lowlights of black, and all the value steps in between. On closer look, however, one can find many red tones as well. The red osier dogwood raises smooth red wands out of contoured drifts. The rose hips are like nosegays on the multiflora hedges, and the mountain ash droops with red-orange baskets, filled with a snow meringue. There are golden willow whips, clusters of frozen wild grapes, and the frosted blue of Colorado spruce. The colors are rich and subtle and grayed, and some appear vivid because of the context in which we see them.

A hint of the growth to come is seen in mosses glowing with clumps of intense green—a moth-eaten velvet carpet flung over a ridge.

Winter branches stitched and couched on cold blue velvet moiré by Judy Pope.

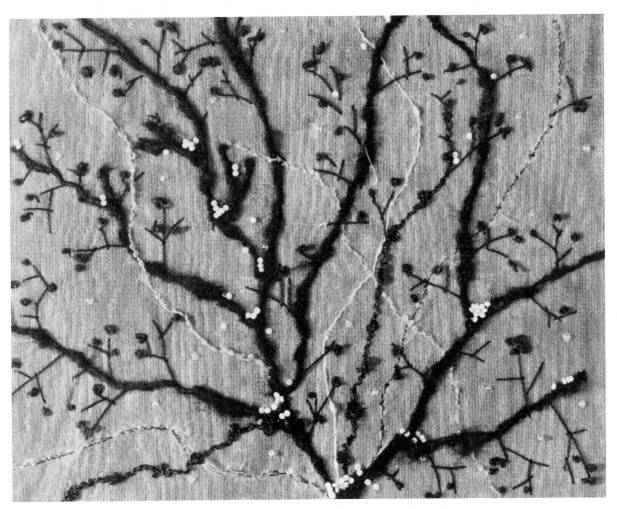

A human spider has added a lacy web to eucalyptus branches. Woven by Patricia Greiner.

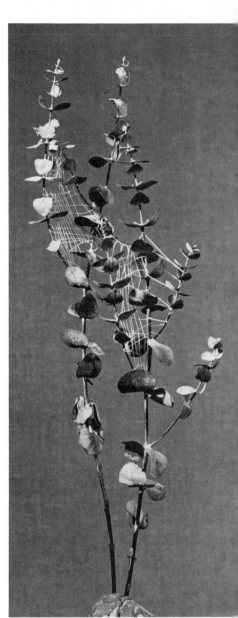

Cashmere and alpaca wrap threads tensioned on a "loom" of haw apple thorns and driftwood by Grace O. Martin.

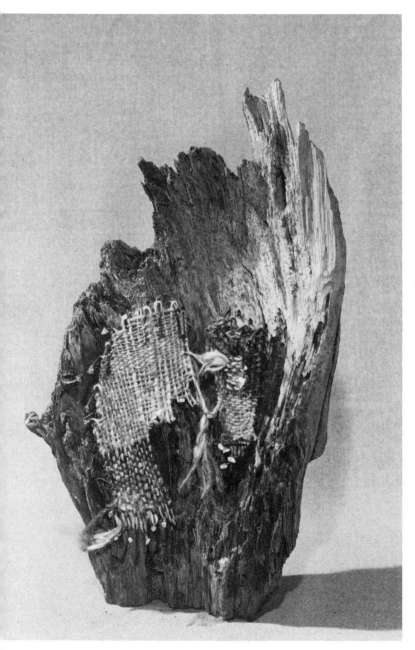

Stylized design of a tree branch and leaves repeated at ninety-degree angles around a square. Hand stenciling on linen by Janice Hannert.

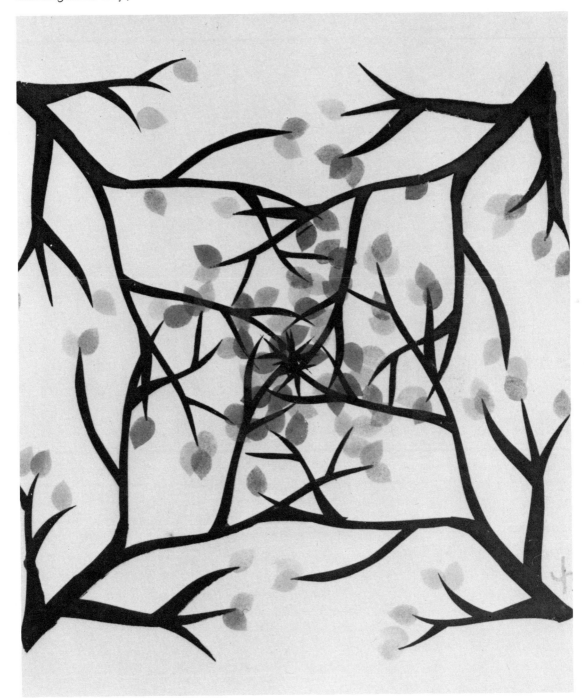

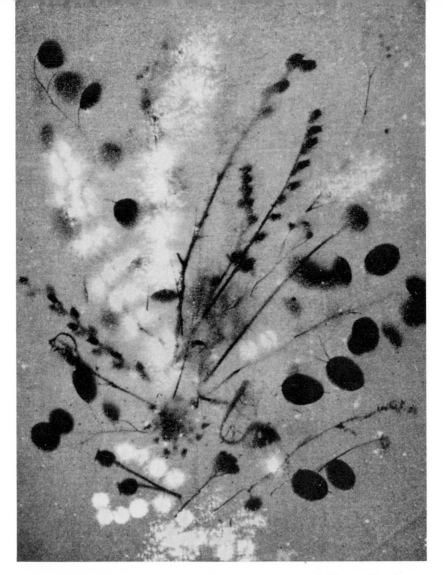

Designing with dry plant materials and color removal: Queen Anne's lace, lunaria, and poppy on light blue velveteen. Design by Nan Refior.

An Awareness Walk

Designing with Threads, Fabrics, and Beads

1. In 3″ × 5″ or 5″ × 7″ filing cards make viewers by cutting out windows in the center of each one. A square, a rectangle or a circle could be used as the negative space, or perhaps it would be fun to try all three. This is your camera.
2. Take a winter walk. Look for groups or clusters of things—look at branches

at bark, at snow, at frozen grasses. Using one of the viewers as a camera, focus on what you find and record what is seen in the viewer with a few quick lines drawn with a black marker on a sketch pad. Get as close to the subject as a rabbit or a squirrel would, so that the resulting picture will fill the whole aperture.

3. Because this is a close-up, it will be impossible to record a whole object, such as a complete tree, all of a drift of snow, or all of a frozen pond. Because this is a partial shot, some of the lines in the composition should extend to the perimeter of the picture. To include all the lines seen would cause confusion, so eliminate any you feel are unnecessary. Record at least six ideas, covering no less than half a page each in the sketch pad.

4. Back home again, evaluate the rough sketches and decide which idea to work on and which shape to work in. Using a circle as the frame of reference is a new way to work for some, and one that can be exciting.

5. Select the materials you might use to develop your fabric design by addition. The background fabric chosen should be one that fills most of the space in the composition. Details can be added with thread and yarns by machine stitching, hand embroidery, or couching. Appliqués of cloth or fur or leather can add texture, and detail can be added with beads, cords, knots. Look for contrasting ingredients—shiny and mat, rough and smooth, coarse and fine.

As this is an inspiration found in winter, the composition might be a white-on-white design. Collect as many different whites as possible. Consider vinyl, wool, silk, lace, cord, seed pearls, all in white, and you will find that there are yellow whites, gray whites, near whites, and whites dazzling as sun on fresh snow.

6. It is possible to give the design another dimension by the use of padding and quilting or trapunto—just as a blanket of snow is quilted by mouse tracks and stitched down with toast-colored grasses. More ideas about these techniques are included in "Discovering Patchwork Patterns: Ideas for Appliqué and Trapunto," following Folio 7.

7. Remember that this is just your impression of a winter cluster, not an exact copy. Experiment by cutting and pinning and planning so the end product will be not just a pleasing picture but rather a mood, an experience, a feeling, just as the impressionists recorded an instant in time on their canvases.

8. When the project nears completion, consider the possibilities for framing your idea. The fabric, to be effective, should be stretched so there are no wrinkles casting shadows. It can be steam-pressed and stretched tautly over a wood frame made of any scrap lumber. A stapler is a good tool to use. If the fabric is tacked down on the edges, the whole can then be faced with wood lath. Using a lath wider than the wood frame or stretcher allows two possibilities: the fabric can be stretched across the front surface so that the design stands out from the wall, or it can be brought across the back of the stretcher to recess the design within it. The broad lath will conceal the tacking. Craftsmanship in handling the framing is important. If you have worked in a circle, you may wish to cut a circle in mat board and stretch your design behind the opening. Be your own severest critic and add nothing that could be eliminated without spoiling the whole effect. Good luck with your miniature textile design inspired by a winter cluster!

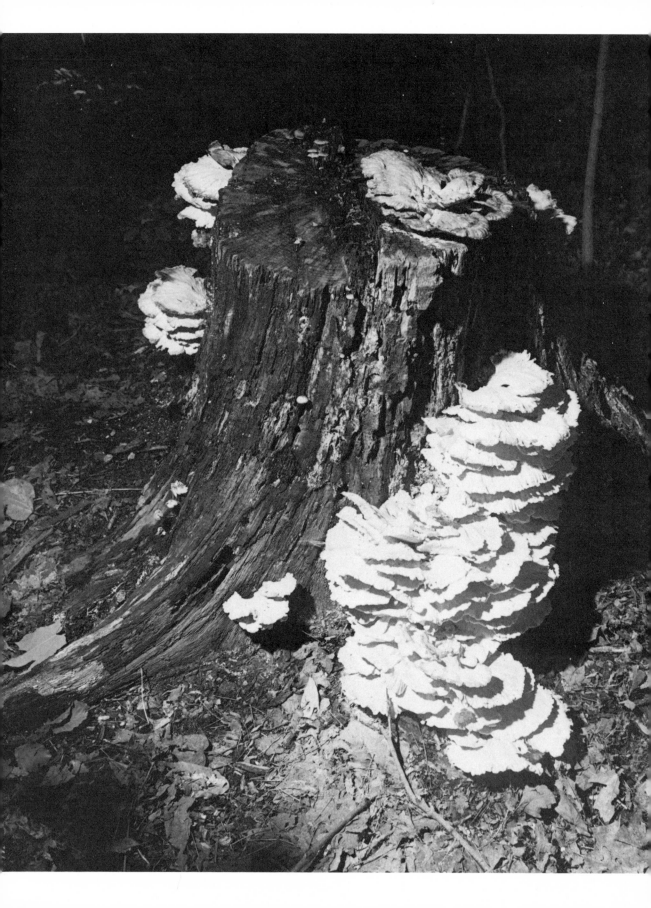

NATURAL DYES

Amber to Umber

Lo! from quiet skies
In through the window my Lord the Sun!
And my eyes
Were dazzled and drunk with the misty gold,
The golden glory that drowned and crowned me
Eddied and swayed through the room . . .
 —Rupert Brooke, "In Examination"

In the liquid sunshine of late April the dandelions explode, making whole meadows shimmer with yellow, "like sparks that have leaped from the kindling sun of summer."[1] In a few weeks bees pack orange-yellow pollen on hairy legs, sunflowers stretch their necks to follow the sun's path across the zenith, and marigolds mound in solid gold clumps along the walk.

The commonest natural dye, in terms of numbers of sources and hue differentials, is yellow—from the bright, singing greened yellow of mullein tea and birch-leaf brew to the yellowed orange from the paper-thin skins of onions, the deep golds of goldenrod bloom, marigold heads, and zinnia petals, and the antique yellows of heartsease, fragrant milkweed clusters, and sheep sorrel—like the grayed yellow of a February sunset. Isak Dinesen, the Baroness Karen Blixsen, who wrote the beautiful *Out of Africa*, was trained as an artist. In *Seven Gothic Tales* she describes, in painterly fashion, an old yellow sky:

> Here and there seaweeds strewn upon the beach marked it with brown and black. . . . The sky was the color of lead, but low along the horizon ran a broad stripe the color of old lemon peel or very old ivory.

The hot July yellows of Canadian or fragrant goldenrod bubble in the dye pot, making a strong distillate of the summer's sunny intervals. The steeping liquor smells like a mai-tai cocktail, the exotic fragrance of passion fruit. It is pure gold and heady, and when it boils over, it is strong enough to stain a formica counter top.

The ruffled saucers of tree conks begin the slow return of a stump to the earth where it began. Photograph by Dick Wesley.

The Chinese pagoda tree also blooms late, and in August the tiny white blossoms (like the flowers in a tin of jasmine tea) cover the ground with dry snow and collect in the hollows after a shower. These can be simmered immediately or dried and stored for years, but the color is always the same—strong carrot yellow.

Dim dawn behind the tamarisks—the sky is saffron-yellow—
As the women in the village grind the corn,[2]

With many of the browns and buffs the dye extracted is the same color as the plant material itself—copper as beech leaves, umber as butternut hulls, and rough and streaky as the heartwood from a decaying stump. In the spring, when sap is running, the golden inner barks of alder and osage orange yield a warm sienna after they have been shredded and soaked and simmered. When sumac lights red torches on the hills, the seed bobs can be collected and brewed to make a tea smelling faintly of raspberry, or boiled in the dye pot to produce a rich wood rose or mushrom beige.

Acorns crushed on the driveway and steeped in autumn rain make drab brown puddles on the pavement, and maple leaves stencil ocher images of themselves on the sidewalks as cold drizzle releases the tannin in their veins. Black walnut hulls of pungent green stain hands that lift them, and for weeks the hard green spheres bob in a barrel, rotting and fermenting, making a black-brown soup like burnt umber paint—a dye that is hard and fast and potent. If you should dye a skein or two and then steep the wool in a pot full of rainwater and rusty nails, it will turn a rich black-brown—a chemical reaction of tannic acid and iron. Another dark tone could be made by using the tannin in sumac leaves. These could be layered with wool in a bucket, soaked for a time, layered similarly again, then plunged into the rusty nail liquor for the same black magic as before.

Nature's time clock winds down. The pasture yellows flicker and go out. "Roses have had their day, and the dusk is on yarrow and wormwood."[3] In the orchard shed apples rumble in the hoppers as "they pour old sunlight into hollow wood."[4]

Gray-green clumps of reindeer moss, a common northern lichen, pave the woods and, with boiling, yield a yellow grayed brown dye like the amber tea of a muskeg swamp. The sulphur yellows of summer have browned and mellowed.

A tree lichen in the Pacific Northwest, *Lobaria pulmonaria*, that masquerades as a bunch of dry leaves cut out of leather and glued to a branch in an ancient maple tree yields a rich gold-brown with long and slow boiling. The lichen dyes are substantive and hence require no mordanting.

The wet leaves in the woodlots are the color of tawny port—a wine that loses its blush when stored in wooden casks that tinge it faintly with brown. Jean Starr Untermeyer liked the color adjective and used it to describe a country road as a continuous strip of tawny silk pinned down by trees. Sassafras roots, when chopped and shredded, fill the room with their spicy fragrance. Simmered in a brass kettle slowly, with urea as the mordant, they will dye a skein of wool a warm and tawny orange.

50

The time for growing is over. The spider eggs are lined up in rows inside the parchment igloos the parents made by gluing three dry leaves together. The bracken is crisp toast. Suddenly, in very late fall, the raveled gold yarn of the witch-hazel flowers appear, softening the stark branches. As Thoreau noted:

> There is something witchlike in the appearance of the witch-hazel, which blossoms late in October and in November, with its irregular and angular spray and petals like furies' hair, or small ribbon streamers. Witch-hazel—a prima donna who missed the curtain call of summer.

Chartreuse to Citron

The constellations wheel slowly in the sky, daylight hours lengthen, and as February days come and go in icy procession there is a new warmth to the sun. Cats pick out a sun spot on the floor to drowse in, and small streams, silent for months, murmur under the ice. The cushions of moss facing south begin to glow with a sort of inner fluorescence. But before these outward signs of delayed dusks and swollen buds there have been growth cycles turning in dark and secret places. The onions in the mesh bag in the dark fruit cupboard now have pale yellow-green sprouts that knit the bag together with chartreuse lacings. These tender shoots can be chopped and simmered to dye skeins of wool almost the same color as the shoots themselves. Earlier in this folio onionskins were cited as a good source of yellow to orange to rust shades, but by using these greening sprouts it is possible to get an early spring shade of greened yellow for dyeing.

As the snow cover recedes slowly, the edge of it steams where the white meets the black of the moist earth. The spring wheat whose late-fall sprouting cooled the red-golds of autumn now makes whole acres come alive with a yellow-green velour that lengthens visibly each day. The willow wands, golden all winter against the drifts, are now a lacy green-gold, and the catkins on the poplars lengthen into fringes of yellow-green silk.

Some connotations of yellow-green, however, are unpleasant—for instance, the off-color shrub that suffers from mineral deficiencies. The color can be the mark of jaundice, of something once white now yellowed with age. It can be the color of poison, such as the infamous liqueur absinthe that leeches poison from wormwood and hyssop. It can be the color of fear—the color of deterioration and neglect. But in the early months of the year it is the triumph of new life emerging from the frozen sod—an Easter of the soul. Henry David Thoreau, who left a rich legacy in his journals, made this entry on June 30, 1840: "In this fresh evening each blade and leaf looks as if it had been dipped in an icy liquid greenness. Let eyes that ache come here and look."

Many green growing things, such as buds, leaves, stalks, stems, and roots, or combinations of these, can furnish the weaver or stitcher with a green dye, but the time to gather them is in this neap tide of the year when the sap is rising in the veins and the growth cycle is turning in earnest. It is possible to secure some

greens or greened yellows at any time of the year, but in other seasons the colors tend to be bronzed or grayed greens, not the clear singing greens of spring. This is markedly evident in the use of the lily-of-the-valley leaves. Picked in May, just after the tightly wrapped spears have unfurled their leaves of a tender new green, the resulting dye is a good, clear greened yellow when fixed with a chrome or tin mordant. These same leaves, picked in August when they have become mature, dusty, leather-like, and static, will yield instead of green a grayed gold or yellowed beige tone.

Some of the greens are not so soluble in water as others. This is true of parsley, which loses very little of its intense green color even after long simmering in soup or long baking in a meat loaf. I have found that generally the juicier plant materials make the best green dyes—spinach leaves being superior to parsley and geranium leaves superior to those from the lilac.

Some of the greens are hard to describe. There are greened yellows and yellowed greens usually called chartreuse. The name comes from the liqueur made by the Carthusian monks at the monastery of La Grande Chartreuse, near Grenoble, France. The secret recipe is said to contain more than one hundred and thirty different herbs, with the dominant fragrance coming from the roots of angelica.

This same lively yellow-green can be called citron, a name coming from the greened yellow fruit of an evergreen shrub. Generally it is the peel of the fruit that is used. It is candied and folded into fruit cakes and other sweet breads at holiday time. The root of the word is the ingredient citral—a pale yellow liquid. Its presence is felt in the yellowed greens of lemon, grapefruit, and limes, as well as in citric acid. The same prefix names the pale yellow-green quartz gemstone citrine and the wind-combed citronella grass in the borders of African compounds.

The weaver or stitcher turned dyer can find many plant sources for colors ranging from chartreuse to citron. A few of them are suggested here, but you are advised to gather locally what is fresh and juicy and prime and to try experimenting. Remember that the color varies with the water used, the time and temperature of the dyeing, and the soil the plant grew in.

Privet leaves will give a yellow green, as will the leaves of the Lombardy poplar, the leaves and stems of heather, and the leaves and stems of fall asters.

In October the coarse stacks of cow parsley with seed heads like the ribs of old umbrellas are very evident in wet ditches, marked by their tall brown skeletons, but in midsummer at the height of the growth cycle they are just as easy to spot. John Alec Baker, in *The Hill of Summer*, tells why: "The aromatic constellations of cow parsley glimmer like a white mist in the meadows and the grass verges."

Using leaves and chopped-up stems together in the dye pot, you can make a good green dye from cow parsley with alum mordant.

Some green dyes called bronze or celadon or grass green or moss green or sage green or mosstone or linden or mallard come surprisingly from nongreen plant material. The dark purple-reds of coleus that make Persian carpets out of flower beds in parks will yield a rich bronze green from the succulent foliage. The red-

purples of heather make a yellowed green, and the blues of lupine and ageratum blossoms also make green. The dye from lupines with a tin mordant is literally green as grass, and the ageratum one will be bright, too, when used with an iron mordant. The red-to-maroon leaves of the ornamental or flowering plum will give, with soaking and simmering, a bright lime green when the mordant is chrome or tin.

But to return to green-hued dye from green plant materials, two possibilities can be cited for the reader to explore—one material very wet and the other very dry. The wet source is seaweed, and most varieties will yield some green dye with boiling. The dry sources are both lichens. The first is the graybeard moss called usnea that is found hanging from tree branches. The second is the moss-like chartreuse lichen that grows in bright tufts on trees. It is found in the western United States at altitudes of about five thousand feet and higher. It, too, makes a yellow-green dye with boiling.

As Richard Jefferies says in *The Open Air:*

> Pure colour almost always gives the idea of fire, or rather it is perhaps as if a light shone through as well as colour itself. The fresh green blade of corn is like this, so pellucid, so clear and pure in its green as to seem to shine with colour. It is not brilliant—not a surface gleam or an enamel,—it is stained through.

For the fiber craftsman to make this strong shimmer of green that looks as though a light were shining through the skeins, it may be necessary to top-dye with indigo. This strong natural blue, secured after great effort from the leaves and stems of the indigo shrub, is described in more detail in the next two sections of this folio. It is itself a pale-yellow-to-colorless dye bath, and it is the process of oxidation that develops the blue color. Any of the strong yellows—easy to procure and covering a wide range from primrose to buttercup to marigold to an onion-skin bronze—can be redyed in an indigo solution. When the wet skeins are exposed to the air, the blue overdye changes the yellow wool to the color of new leaves glimpsed through a rain-striped window. In West Africa after the first March rain this same instant green streaks across a savanna grown sere and dusty after six months of drought. The more times a skein is dipped in the blue and then allowed to hang in the open air the more color will be added to the original yellow and the richer and more intense the resulting green will be. Immersions of just a few minutes will add a faint blue wash to the yellow, but skeins left in the dye for half an hour or longer will pick up more blue and turn a more verdant green.

Green is the color of life, and green dye is made from living plants. The resulting shades are not countable. Twenty different leaves collected and lined up edge to edge will make a green stripe made up of twenty different shades. Green is a cool color but one that warms the heart.

Earlier I have used a passage from a journal of Thoreau—a writer who carefully recorded his ideas about nature, philosophy, and life. Another and earlier

writer who filled many journals with her thoughts was Dorothy Wordsworth, a sister of the British poet William Wordsworth. They had a very close relationship, and she enjoyed helping him in his writing. In fact her entry about discovering a clump of daffodils "fluttering and dancing in the breeze" evokes the same word picture as his well-known daffodil poem. In her entry of February 24, 1798, she records many different shades of green seen on one of their walks together. The craftsman working with natural dyes could match these and add many more:

> Went to the hill-top. Sat a considerable time overlooking the country towards the sea. The air blew pleasantly round us. The landscape mildly interesting. The Welsh hills capped by a huge range of tumultuous white clouds. The sea, spotted with white, of a bluish grey in general, and streaked with darker lines. The near shores clear; scattered farm houses, half-concealed by green mossy orchards, fresh straw lying at the doors; hay-stacks in the fields. Brown fallows, the springing wheat, like a shade of green over the brown earth, and the choice meadow plots, full of sheep and lambs, of a soft and vivid green; a few wreaths of blue smoke, spreading along the ground; the oaks and beeches in the hedges retaining their yellow leaves; the distant prospect on the land side, islanded with sunshine; the sea, like a basin full to the margin; the dark fresh-ploughed fields; the turnips of a lively rough green. Returned through the wood.

Flame to Fuchsia

The rain-soaked dead bracken had now opened and spread out its shrivelled and curled-up fronds, and changed its colour from ashen grey and the pallid neutral tints of old dead grass to a beautiful, deep rich mineral red. It astonished me to think that I had never observed the effect before —this marvellous transformation of the sere and almost invisible lace rags to these rich red fabrics of curious design spread upon the monotonous dark green bushes like deepest red cornelian or reddest serpentine on malachite.

William Henry Hudson, *Birds and Green Places*

The natural liquid reds come obviously from red things—flower petals and fruits, rinds and berries, dried scale insects called cochineal, thickened tubers, such as beets, juices of roots, such as bloodroot, and wild black cherry. They also come mysteriously from things unseen, such as the inner bark of bayberry and dogwood and the acids of orchil or achil-producing lichens. In all of them there is the dramatic entrance of warm color to add to the subtle grays and golds that the natural dyer accumulates most easily.

In brimming basins of liquid orange or bittersweet or burgundy red, the dye liquor seems to come alive and glow—like the opalescence of red currant jelly

in glasses lined up on a sunny windowsill. The red dyes vibrate with a richness and vitality matched by the northern landscape in the autumn of the year.

The addition of the warm skeins to the dyer's palette—like the addition of a single branch of red maple leaves to a solidly green woodlot—unlocks a Pandora's box of dramatic effects. Some of the dyes are a subtle pinking of beige, but others are undiluted orange as startling as an exclamation point. They glow with the gay colors Susan Fenimore Cooper wrote of in *Rural Hours*.

. . . like some great festival of an Italian city, where the people bring rich tapestries and hang them in their streets; where they unlock chests of heirlooms, and bring to light brilliant draperies, which they suspend from their windows and balconies, to gleam in the sunshine.

As described earlier, some of the flame-to-fuchsia dyes are held fast to the wool by chemical mordants that act as anchors for the dye or as catalysts to trigger color variables.

Orange, of course, is the color resulting from the addition of any red tone to yellow or gold. There is a whole range of possibilities, from high to low and from dull to sharp, reflecting tones Jefferies found in nature: "A red light as of fire plays in the beeches, so deep is their orange tint in which the sunlight is caught." Oranges can be formed by top-dyeing with one of the easy-to-use reds, such as cochineal or madder, in varying dilutions over the ubiquitous yellows, but some of the plant dyes contain intrinsic orange tones themselves.

The thin skins of onions contain a dye that ranges from a warm gold to a rich orange, depending on the mordant used, the temperature of the dye liquor, and the original onion color. Basically, the brown and red skins intensify the golds, tin brightens them considerably, and chrome (a warm saffron color itself) bronzes the gold tones. The dye is so strong that a small piece of onionskin can make an old-gold print of itself on a kitchen sink. *Boletus edulis*, one of the edible mushrooms that pop up in pine woods in a moist fall in Michigan, will also yield yellow-to-yellow-brown dye.

Another large mushroom family is the Russula group. These have a firm cheese-like flesh, but in some of them a thin shiny skin of strong pink or fuchsia covers the top, becoming slimy as the mushroom ages. Some of the Russula, such as fragilis and emetica, are poisonous. This easily peeled skin of hot pink or rose or fuchsia can be simmered to produce a soft shell pink on skeins of wool.

One of the most delightful surprises I have ever lifted steaming from the dye pot was a brilliant coral or papaya pink. This completely unexpected color came from a pot of dye made from bronze-yellow mushrooms with yellow-tinged stems and dark gills (probably one of the Flammulas, such as alnicola or picrea). These were picked from the rain-soaked carpet of a pine plantation and used with a tin mordant. It is these startling discoveries that make a dyer glow like the wool.

The multipetaled heads of marigolds also provide a rich yellowed orange that is dulled slightly by using dried flowers instead of fresh blooms. My students have made dye from marigolds that had been stored for four years. The resulting color, mordanted with chrome, was a deep cadmium orange, like baked Hubbard squash.

The lichens, those slowly forming simple plants that can be found on bark and boulders, have been described by John Ruskin as being "strong in lowliness," "constant-hearted," and again as "slow-fingered." Most of the lichens layered with skeins of wool in the dye pot will yield brown tones when simmered slowly for a long time, but the chartreuse variety found on trees at high altitudes in the West and the orange ones, Xanthoria, can be induced to add their own bright color to the wool. The bright orange lichens are firmly attached and often in inaccessible places, such as on a sheer rock face near falling water. John Ruskin's description gives a hint of their ageless beauty:

> . . . to them, slow-fingered, constant-hearted, is entrusted the weaving of the dark, eternal tapestries of the hills; to them, slow-pencilled, iris-dyed, the tender framing of their endless imagery. . . . far above, among the mountains, the silver lichen-spots rest, star-like, on the stone; and the gathering orange stain upon the edge of yonder western peak reflects the sunsets of a thousand years.

Some of nature's orange accents lighting up the green are disappointing when gathered for the dye pot. In July the hawkweed forms shag carpets with red-orange tassels on the end of each strand. These fold up at dusk and in the morning light the ground with a splendor that excites the dyer but dismays the farmer who sees the plant as a weed.

In the swampy hollows a highlight of orange discloses a clump of butterfly weed that blazes like a rocket. This attractive member of the milkweed family gives a good yellow dye with the flower heads and a yellow-brown from the roots. Distinctly orange tones, however, can be made from the roots and stems of the smoke tree, and a duller version from the inner bark of the osage-orange tree whose knobby green grapefruit-size fruits are sometimes called Missouri hedge apples.

One of the dyes of early spring, when, Wendell Berry says, "bloodroot rises in its folded leaf" comes from this small plant. The dye, in the resinous sap of the roots, is a pale red-orange and fast in color. A harbinger of spring, this early bloodroot, which Kipling found "green against the draggled drift, faint and frail and first," gives the weaver a red dye, but in many places this ground-hugging, white-flowered plant is on the protected plants list. The fiber craftsman should enjoy its beauty in place and buy bloodroot dye from a commercial supplier instead.

Red has been described as the essence of life, of joy itself. Reds are exciting! Traditionally they have been used for festive occasions—heightened color for heightened feelings. In parts of India a bride is wrapped in a red sari and wears flame-colored sandals on her feet and lacquer-red bangles on her wrists. Nature provides many possibilities for red dye with subtle differences in value and hue, and the dyer can amass a graded color wheel of closely related yarns in the red range. Starting first below the ground level are the roots of bedstraw. This low-growing plant with its four-sided stems and small four-petaled flowers was said to have furnished the legendary straw for the manger. Springing from the fallen trees and decaying stumps are mushrooms and fungi with hints of pink or orange that can be

56

used to make pale red tones. Hugging the earth, there are the plants that will yield wild strawberry stains, the fuchsia of blue-berried clintonia, the pinks of blueberry and rose hips. Rising slightly taller are high-bush cranberries glowing like Mexican fire opals after the first frosts. Other reds can be produced from currants and the heavy umbels of red elderberries, bright as geraniums against a green lawn.

Other low-growing plants yielding reds are not berries but weeds. Using the whole plant root, the stem, and the knobby green seeds, the dyer can get a strong rust-red from lamb's quarters. The same is true with another member of the sorrel family—the maple-leafed goosefoot. Sometimes the wool hesitates to hold the color, and sometimes the brilliant dye liquor browns with too much simmering.

Reds from the taller bushes and small trees include the large cherry family—pin, Nanking, sweet, sour, and choke, and the wild black cherry as well. These yield primarily thin pink or salmon-colored dyes, such as a rosé wine that can be used to dye wool for warm accents in crewel and canvas embroidery and for jewel tones in rya rugs. They are subtle, soft-spoken hues whose redness may not show up until a skein is put next to one in the green range. Wool can be dyed a delicate shell pink with the rose-to-pink skins that top the basically white mushroom called Russula emetica. To get a vibrant red that swings toward rust, the dyer should experiment with marjoram tops. These give a richly dark red-brown dye full of the glory of November.

A present-day weaver famous for vibrant warm colors in her constructions is the Polish artist Magdalena Abakanowicz. Gallery viewers have been stunned by the gigantic strength of her three-dimensional tapestries. These are enormous hanging forms in yarn, sisal, and flax that she weaves in rusty browns, orange, and full-bodied reds. The weft is packed so tightly into the warp that when the huge structures are hung from the ceiling they become an almost living presence—a textile environment. Viewers are literally enclosed by the tapestry. It is as though one were inside a giant sequoia, touching the heartwood—or were wrapped in a rough blanket lifted from the forest floor.

Earlier in this folio many sources of natural red dyes have been given, but to get a really startling, full-intensity red the craftsman using natural dyes to color his wool must go to two reds known to the ancients: carmine from the bodies of the insect cochineal, and alizarin crimson from the roots of the madder plant.

Let's look first at the tiny scale insect cochineal, whose body contains carminic acid. When the Spaniards invaded Mexico early in the sixteenth century, they found people using cochineal for face dye. This strong scarlet color is found primarily in the eggs of pregnant females. Dried insect bodies, the size of a coffee grain, are used as is or ground into a powder. The dye is potent and fast. With a tin mordant it dyes wool carmine; with chrome a deeper purple-red; with alum an American Beauty red. The dye takes on a fuchsia tone when a small amount of vinegar is added.

Some writers include cochineal in books on vegetable dyes. This is incorrect, since the dye is not plant but animal in origin, but sometimes a writer defends his position by stating that cochineal red is the same color as the cactus flowers on

which the insect feeds. The insect extracts the carminic acid, and its body, especially the egg case, is the receptacle for the color.

The root of the madder plant containing the colorant alizarin was for a long period the most important of the red plant dyes. Pliny described the dye as being used for mummy wrappings, and Virgil described how the pigment reddened the bones of pigs that fed upon it. Madder grows readily in Europe, especially Spain, and also in India and Central Africa. It is a perennial with a four-sided stem, whorls of leaves, and small yellow flowers followed by red berries. It is the inner roots, several feet long, that contain the dye; the outer bark is usually discarded. Using madder purchased from a supplier as roots or roots ground into powder, the natural dyer can with care produce a red palette. When only madder and water are used, rust red is produced. Some early double-woven coverlets warmed frontier cabins with this ruby wool. With a chrome mordant this dye becomes strong orange, and with alum and other weird and secret ingredients it became the famous Turkey red of the ancients. With an iron mordant the red disappears and the wool becomes black.

A fairly common annual, pokeberry, that grows in the cooler parts of the United States furnishes the dyer with shades ranging from cerise to fuchsia. In the fall the red-purple berries, dripping with juice, hang down in grape-like clusters; the twigs are also fuchsia-red. The plant likes moisture and rich humus and thus is often found in moist, brush-filled hollows. Some Indian tribes used the berry juice for facial decoration; pioneer children on the frontier also used it to color the cheeks and lips of their corncob dolls. The dye is easily extracted from the berry clusters in a dye bath that is half vinegar and half water. The skeins simmered in a pot of this red ink come out glowing with color. Unfortunately sometimes the glory will lighten with time. Wonderful rust reds result from top-dyeing pokeberry over one of the strong golds, such as those from onionskins, marigold petals, or birch leaves.

As increasing amounts of blue are added to red, the color cools and becomes fuchsia, magenta, red-violet. As the proportion of blue increases and dominates the red, the dye becomes rich heliotrope, grape, blue-violet, and purple.

The plant source of these strong, vibrant hues, startling in their impact when knitted or woven next to the complementary golds and green-golds, is the group of simple plants called lichens. To get these vibrant colors, specific lichens (those containing orchil or archil) must be collected, dried, and crumbled, and then macerated with ammonia or urine for a time. One recipe calls for five years of brewing. During this period the dye is stirred daily to incorporate oxygen, and the lichen bits swim in a reddening liquid that moves slowly from rose to strong, full-intensity purple. The mixture can be kept for years. Small amounts may be taken out for dyeing, and additional crushed orchil-type lichens and ammonia added to perpetuate the mixture. This is a substantive dye, which means that it requires no mordanting. Like litmus paper, which is colored with orchil dye, the orchil dye reddens with acids and blues with the addition of an alkaline substance such as soda. There are currently several good books on the market that will help identify these dye-producing lichens.

There is an emotional involvement when dyeing with reds, and it is almost a religious experience to lift dripping skeins from a dye pot filled with liquid red. The subtle pinks and warm beiges, the near reds, are the organ prelude, opening softly in the empty sanctuary. The true reds, full and vibrating, are sunlight streaming through ruby glass, a full choir with all the organ stops out and trumpets sounding in the narthex. Begin with the prelude and lead up to the fortissimo of cochineal and madder. You will feel you are waving a skein of Old Glory.

Driftwood to Smoke

"And the grey rains are on the hills
And a grey dusk is over the world."
—Oscar Williams, "Grey"

Great things happen to a piece of a spar abandoned in the sea. The tumbling over and over in briny water and quartz-sharp sand, the alternate soaking and drying, the bleaching pull of the sun all work their own peculiar magic on the wood. Slowly all extraneous parts are removed until, finally, only the heartwood remains. A patina is laid down that ranges from pearl to pewter, depending on the kind of tree the wood came from and the number of weeks it has spent on the beach. Its beauty is exclaimed over, and it is picked up and carried home triumphantly.

Many lovely things are gray. There is something warm and inviting about it —a color with a built-in tactile quality of its own. Some of the shades have been given names that reflect this feeling—like the moth that is called dusty miller, and the bedding plants called pussytoes or lamb's ears that form a border of quaker lace around a planting of poster-red geraniums.

Some gray things have a built-in aroma as well, and when the word is spoken the smell comes too—the scent of a greige ribbon of wood smoke lazing up from a mountain cabin in October, or of a ribbon, vesper blue, of smoke rising from a mesquite fire on the canyon floor, the odor of silvered fish scales lighting up the sand, or of early-morning mists rising over saltwater marshes and carrying with them the clean, iodinic fragrance of the sea.

Sometimes the gray is only a bloom, not really covering but merely masking slightly the hue underneath it. This soft gray smokes up the red of raspberry canes, dusts the purples of wild grapes and blueberries, and coats with fur the Russian olives and the apricots. It is a temporary, fleeting gray to be polished off on a blue-jeaned knee. These grays give just a hint of the strong color they mask, and in dyeing wool it is easy to get a pink-gray, a blue-gray, a greened gray—a soft shroud draped over the color. Bayberries, white as hearth ashes in the morning, appear light gray because of the granules of wax that stud the tiny spheres. It was this wax coating, surfacing in the pot when the berries were simmered, that was skimmed off and used for dipping bayberry candles. When the candles were lighted, they filled cabins with this special incense of the maritime colonies,

59

blending it with the spicy fragrance of sassafras tea and clove-studded pomander balls.

Like a village sleeping under a fog comforter, gray tones have no hard edges. Each spills over into the next one, and they run the gamut from highlight to lowlight, with hundreds of nuances between. In nature-dyed gray skeins the differences are so subtle that they may not be visible at all except when the skeins are ranged up together and their lightness or darkness and any traces of yellow or blue, or warm or cool color, become evident. They are mood mirrors.

If you start at the top of the scale, you begin with the highlights grayed just slightly over white—near whites like that of the lining of a copper kettle newly tinned, or a silvery canoe birch spotlighted by a rising moon, or milkweed parachutes floating in space when frost has pulled the rip cord. Light, silvery grays they are, closer to white than to gray.

There are several growing things that yield a gray dye to use with wool, but any of them could be used in weak dilutions or in short dye baths to give the thin ephemeral grays. Sunflower seeds lined up in tight spirals inside the huge flower heads give a good gray when combined with an alum or tin mordant—a cool yellowed gray like a winter sky heavy with snow. Skeins dyed quickly will be a near white, as will the ones put in a pot of dye colored with blackberry shoots, picked while they are still green.

The weaver, rug hooker, or stitcher looking for middle-value neutral grays to complement bright-colored skeins could use yarns mordanted with iron in the form of ferrous sulphate, whose common name is copperas. The same effect could be achieved by using an iron kettle for the dye vessel. In colonial times the wool was spoken of as being "saddened" by the iron. Some interesting dyes to try are those from elderberries, buckthorn drupes, rhododendron leaves, butternut hulls, and alder catkins. The tissue-paper skins on hyacinth bulbs can be collected and used to make a blued or purpled gray like a night sky in February, or like a July sky heavy with thunderheads and foreboding. The same dark blue hinting of purple can be brewed from the fruit of the mulberry tree that stains sidewalks with its inky splashes. Years ago this color of ink was called midnight blue. The petals of hollyhocks, dark red and violet, also make a rich black-blue dye. To get purple-blue tones try Oregon grape, wild blueberries, or blackberries, heavy with juice.

When the dyer needs to move from a warm gray to a darker tone with the accent on blue, he needs to find a source for a definitely blue dye—either a cold Nordic one or a warm purple tone. The cool blue dye from a botanical source is one that is both ancient and contemporary—a potent blue from the leaves and/or stems of the indigo plant.

This permanent blue color was described by Marco Polo when he returned to Venice with his tales of fabulous cities far to the east. Indigo was a dye he already knew about at home in Italy, but he recorded carefully the preparation of the dye as he observed it in China: "There is also plenty of good indigo, which is produced from a herb: they take this herb without the roots and put it in a big tub and add water and leave it till the herb is all rotted. Then they leave it in the

sun, which is very hot and makes it evaporate and coagulate into a paste. Then it is chopped up into small pieces, as you have seen it."[5]

Indigo is not a plant juice or stain; it is a colorant that is extracted from the plant physically by pounding and chopping and chemically breaking down the plant tissues, releasing the colorless dye, originally with urine and later with ammonia and now with caustic soda or lye.

The dye pot is filled with a slightly green-yellow liquid. A skin floats on top, as on the surface of an unused rain barrel. There is a strong chemical smell, like that of new blue jeans worn in the rain, but no hint of the exciting color to come. The wet skeins are immersed in the pot, slowly and carefully, so as not to stir or disturb the contents more than necessary. After twenty minutes the slightly yellowed wool is lifted out, and as though a magic wand were waved, it turns blue as soon as the air hits the wool. The dye is itself colorless, as was the ancient royal purple dye extracted from murex shellfish, and the traditional blue color develops only after oxidation has taken place. After half an hour the skeins can be immersed again. With each successive dipping the blue is intensified. If too much oxygen enters the pot, the dye becomes inert and must be reactivated before further dyeing can take place. More hydrosulfite solution is stirred in slowly to drive out the oxygen and return the liquid to a pale yellow-green. Indigo grains or paste can be purchased by the pound from commercial suppliers. There are several methods of putting the indigo into solution, and the novice should experiment with several, following the directions very carefully.

Indigo is the color of the Tuaregs of North Africa, the "Blue Men of Morocco." The flowing garments and turbans of these nomadic desert people living in and around the Sahara are indigo-dyed. After long usage, some of the loose dye in the cloth also colors their skin. This gives them a look of cool strength, one in which their garments and bodies seem to be cast in the same mold.

Indigo is the strongest natural blue. Early Britons marked their faces with blue dye from the plant called woad, but today indigo is used by more people in more places than any other blue. In West Africa blue is the tribal color of the Yorubas—the cool deep blue of indigo. On market days in Western Nigeria the crowded lanes and stalls are a mosaic of blue garments, plain and patterned, dark and light. Perhaps each piece of a woman's dress will be detailed with a different motif. The fabric may have been printed with a stamp carved out of a calabash or tie-dyed by pleating it and tying it with raffia. It is a handsome sight. The blue brings out the warm sienna of the skin, and the living mural is tessellated with pyramids of grapefruit on plaited trays; hands of green plantain, the cooking banana; baskets of green-gold oranges and dried chili peppers. But the constantly recurring theme is indigo.

Indigo dye is a cool blue. To get a less austere blue or one hinting of warmth and purple, it may be necessary to top-dye. This consists of taking skeins previously colored with a light tone of rose or coral or peach or lavender, all of which have antecedents of red, and redyeing them in a pot of gray or grayed blue dye, such as those taken from rhododendron leaves or hyacinth petals or some barks. This is the

equivalent of putting a gray wash over a portion of a watercolor painting that needs toning down. Some of the blue berries—wild grape, clintonia, blueberries and blackberries, or the fruit of the Virginia creeper—provide the warm dusky grays of mountain shadows after the sun has dropped below the peaked horizon.

The craft of dyeing with ingredients gathered from woodlots and fence rows is a fascinating one, and it is easy to become an addict. The act of lifting glowing skeins dripping with color has been described as being close to a religious experience. There is an adrenalin-like surge of pleasure. Years later this feeling can be recaptured by running a skein through the hands, tactilely remembering the color. There are several methods of dyeing with found materials. Some dyers brew the dye and strain out the leaves, berries, or whatever before immersing the skeins. Another way is to tie the plant material up in a cheesecloth bag, as if it were a chef's garni for soup. I prefer the method called layering, in which the leaves or roots or berries or petals are put in alternately with the wool skeins so that there is an intimate connection between the live color and the live wool. It becomes an intimate blend.

When the dye process has been completed and skeins have been neutralized or oxidized and squeezed through mild suds, rinsed in rainwater, and hung on a branch to dry in the sun, there is a temptation to hold on to the experience by shaking out the strands, squeezing out the wet end of the skein, and making a damp palette of dyed tones. In colonial times, when wool yardage for a new suit or plaid for a jacket was woven and the last weft pick was thrown, the bobbins wound up, and the empty shuttles lined up in neat rows on a shelf, the weaver soaked the loomed cloth in warm suds. Then family and friends sat barefoot in a circle on the board floor and kicked the cloth around from one foot to another. This was the process of fulling, in which gentle tossing raised the nap on the yarn and filled the spaces between the threads. With a difference like that between the connotations of the words "house" and "home," the yardage now became not just an interlacement of threads, but an original fabric—loomed by hand.

Taking a Color Tour: *First Steps in Dyeing*

Early dyes were probably accidental discoveries. Berries or bark or earth stained the deerskin clothing or the hands, but this same color, controlled, was an exciting development. Fiber craftsmen today, who work with natural dyestuffs and who walk long distances searching for materials and who then cut and soak and brew their finds, realize how strong this color urge was in early peoples. Discovering disks of orange lichen high on a vertical canyon wall where a mountain stream crashes noisily on its way, one looks at the inaccessible dyestuff and wonders.

The suggestions here emphasize the use of natural wool because it takes color beautifully and is also easily available today in places where knitting and craft yarns are sold, as well as in craft shops catering to weavers. Animal fibers (wool, silk, or hair) are the easiest to dye. Plant fibers—cotton, linen, and jute—do not

accept dye as readily, never as brilliantly, and seldom hold it as long. Cotton dyeing often requires high temperatures and long dye baths that make the color drab. Most synthetic fibers are designed to reject moisture so that they will be slow to wrinkle. They can be colored with vegetal dyes, but most of the color returns to the rinse water. The procedures for dyeing wool are simple but rewarding:

1. Collect four enameled pails and a clean stick for each one. An expensive substitute would be four stainless-steel pots and four wooden spoons.

Buy a pound skein of natural wool, one that is the same off-white color as when it was sheared from the sheep's back. It is best not to select too fine a wool because it may tangle, but wool in a size similar to knitters' fingering or sport yarn will work very well. Divide the skein into five smaller ones and tie each one loosely in two or three places.

2. Before any dyeing can take place, the wool must be scoured. This process removes any natural or spinning oils that waterproof the fibers and keep the dye out. Wet the wool thoroughly. Squeeze out all the air under water. Into each pail put a small amount of mild soap and enough water to cover the damp wool. For all parts of the dyeing process it is best to use distilled water, rainwater, or well water that hasn't had chemicals added to it. As there are five skeins and only four pails, one of the containers will have two skeins in it. If you have a four-burner range or a large outdoor fire box, you can heat all four pails at once. Slowly bring the water to a simmering temperature, hold it there for twenty minutes, then cool and rinse the yarn well to remove all traces of the soap. Hang the skeins up to dry and fluff them in the wind.

Now each of the five scoured skeins needs to be broken down into eight to ten smaller ones.

3. It is possible to find many dye sources in nature that will color wool with simmering only, but the addition of specific chemicals called mordants to the bath will make the dye adhere or bite onto the fiber and insure fastness. It may also slightly alter the color. These chemical mordants were known and valued by the ancients. Some were found in rocks, in seawater, in urine, in the ashes of cooking fires, in leaves and galls. Some came from the iron, copper, or brass kettles in which the dyestuff was brewed. In this experiment we will be using the four most common mordants. There are many others. (Because of the current interest in natural or vegetal dyes many yarn suppliers now stock mordants. The alum mordant called for is *not* the same as that used in the kitchen, but the cream of tartar is. The chrome is potassium dichromate, which is used in photographic developing and printing, so photo stores would be able to supply it.)

4. From the pound of wool you should now have about fifty small skeins, scoured and ready for mordanting. Divide them into five piles. The first group will have no identifying mark, indicating that no mordant was used. Groups two, three, four, and five will be identified by tying a series of knots in the holding thread to indicate which mordant was used:

one knot—alum three knots—copper
two knots—chrome four knots—tin

63

5. Prepare the four mordant baths as follows:

ALUM
1 gallon water
1 tablespoon aluminum potassium
sulfate (alum)
1 teaspoon cream of tartar

CHROME
1 gallon water
⅓ teaspoon potassium dichromate

COPPER
1 gallon water
1½ teaspoons copper sulfate

TIN
1 gallon water
½ teaspoon stannous chloride
1 teaspoon cream of tartar or
oxalic acid

Sprinkle the chemicals into the water and stir to dissolve. Enter the thoroughly wet skeins and slowly bring the solution up to a simmering temperature. Cover the pail and hold it at this heat for half an hour. Allow the skeins to cool in the pails and remain there overnight. Next day discard the liquid, rinse and store the wool. The chrome-mordanted skeins are light-sensitive and should be kept in opaque plastic or paper bags until they are put into the dye pot.

There are many natural dyes one could begin with, but an exciting one, always available, is that from onionskins. Collect two or three packed cupfuls of either white, red, or gold onionskins or an assortment of all three. Put them in one of the enamel pails, cover with water, and allow to stand from four to six hours or overnight. From the stored mordanted skeins select one from each of the groups —i.e., alum, chrome, copper, and tin—and one from the no-mordant group until you have five of them tied together with a long piece of wool. Soak the quintet of skeins in water until every fiber is wet. Enter this group into the cold onionskin dye and slowly bring it up to a simmering temperature. The dye may even be allowed to boil for three or four minutes. It is at this higher temperature that the strongest gold colors develop, but too much heat can make the wool harsh and lifeless. Every twenty minutes or so lift out the yarn group by the long cord to watch the handsome yellow-orange color develop. You will be amazed at the five different shades produced in the one dye pot. To get more color variables, some skeins could be removed after an hour and some left to cool in the bath overnight. Some dyes become more intense with longer and hotter brewing, but in some the high, true color is fleeting and easily lost or browned with too much heat or time. It pays to keep testing when working with these natural colorants.

If you enjoyed this golden time, use the other skeins to try dyes from marigold petals, birch leaves, Queen Anne's lace, mullein leaves in March, or goldenrod in August for other singing yellows. Some of these can be greened by adding ½ teaspoon of ferrous sulphate or a few tablespoons of liquid from a jar filled with rusty nails and water. When you see these skeins of gold wool, you will glow, too. Once again, a word of warning: dyeing from nature is an addiction. There is no cure. You will always need one more pound of wool—one more high from lifting one-of-a-kind jewels gleaming and dripping from the dye pot to color your day.

1

2

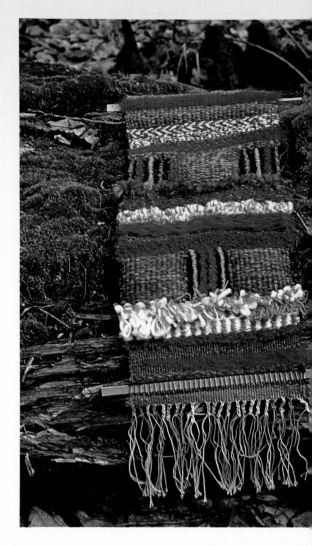

3

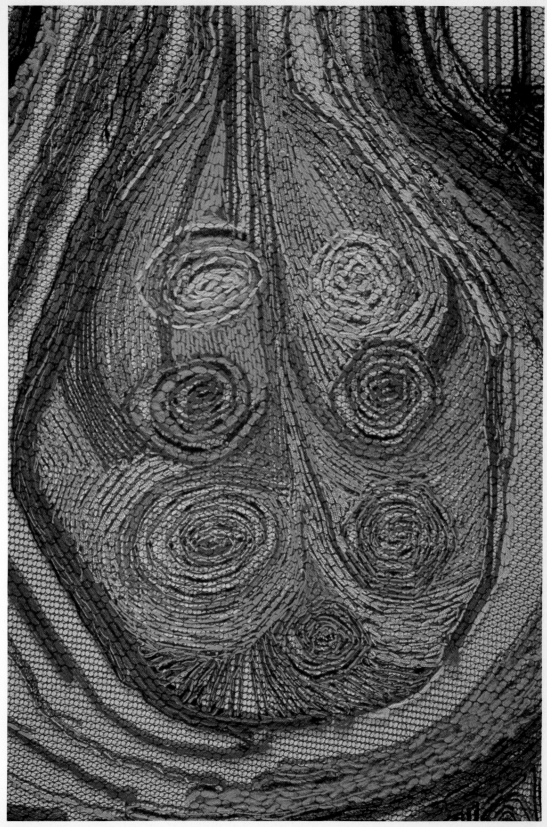

5

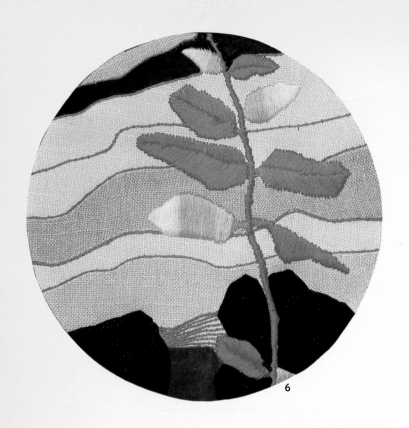

6

7

8

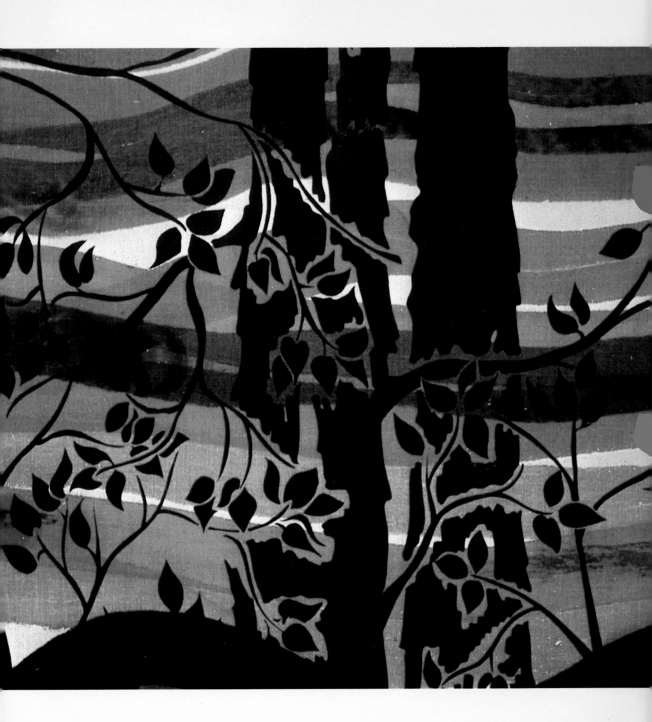

9

10

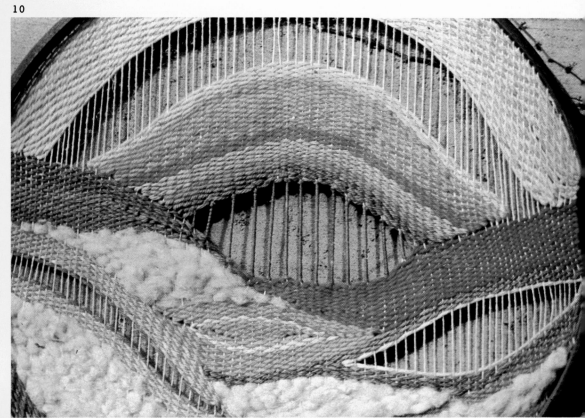

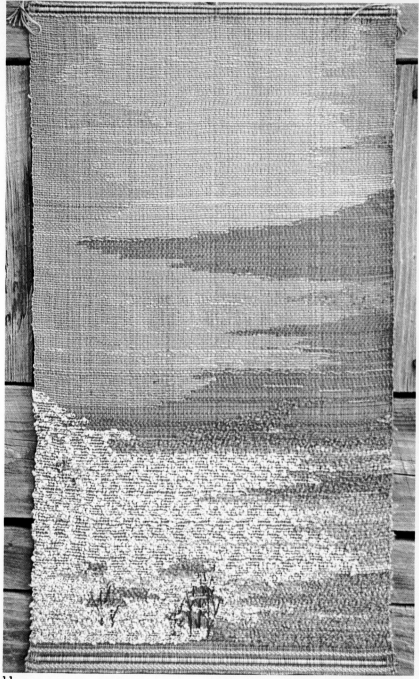

11

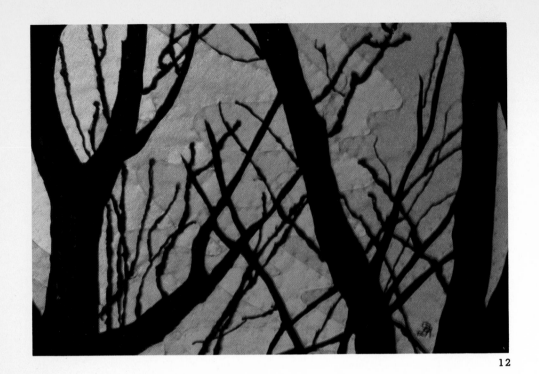

12

13

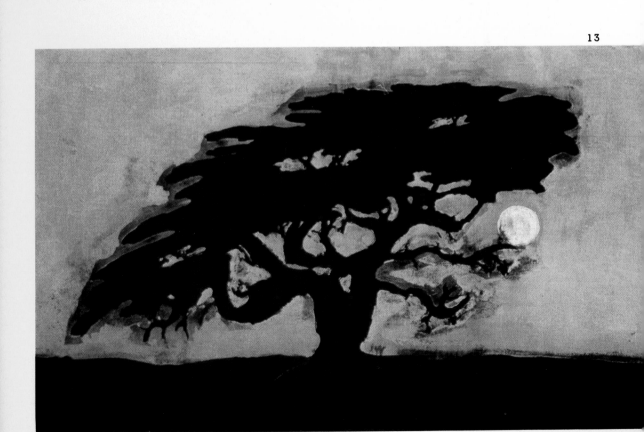

List of Plates

1. Tree verticals against the sky interpreted in reverse appliqué by Karen Healy. Strips of felt were applied to a dark background, then cut away to reveal the fabric underneath, forming the trees and branches.
2. Woven sunset sky "painted" in thread on a linen warp by Melissa J. Brown. Rough wool and cotton were beaten into place with a comb, with shorter lengths inlaid. Finger manipulation of some weft threads in a Soumak technique added another dimension.
3. Ninety separate tapestries needle-woven on a small frame by Reiko Hirosawa and darned together, using the warp ends. Photograph by Robert E. Smith.
4. Raised double-woven "pillows" on a sampler inspired by a moss-upholstered log, woven by Karen Parker. Openings that suggests hollows in the log were made by wrapping the weft around the warp. Photograph by E. C. Martin.
5. *Genesis.* New life beginnings expressed in silk, wool, and linen by Grace O. Martin. Darning, the simplest of textile techniques, made it possible to lace colors in and out of the nylon net base, changing them at will.
6. Shelley Walters pieced strips of linen together to form a sky, then satin-stitched leaves and a stem over them. Black organza, puffed and folded, suggests rocks at the base.
7. *The End of a January Day* by Laurie Mercer, a sky sketch colored with felt pieces stitched to black cotton. Color is subtracted in jagged strips to show the black.
8. The memory of a Finnish summer preserved on fabric by Sharla Jean Hoskin. Dye was poured into an open-ended juice can and the liquid color drawn across the cloth. A design cut out of lacquer film and applied to a silk screen was used to overprint the trees on the bright sky.
9. A trio of birches created by Jan Hughes in stuffed appliqué with short stabbing stitches of brown thread and frayed yarns.
10. Living color can be extracted from fruit, seeds, leaves, bark, husks, and even roots. Janet Marheine Jipson dyed wools with birch leaves, goldenrod flowers, carrot tops, and onion skins to make a needle-woven mandala.
11. A swamp in winter as seen through a window. This hanging, woven by Sandra Dungworth on a fine grayed warp with inlay and interlocked wefts, captures the awesome simplicity of winter. Photograph by E. C. Martin.
12. A February sky depicted by Diane Augustine. Reverse appliqué in felt with bouclé threads couched on to make gnarled twigs.
13. An evening silhouette batiked on velvet by Jane Werner. The color of the original fabric shows in the moon. The entire sky was waxed over to resist the dyes at one stage; only the tree and the dark foreground show the sum of all the dyes used.

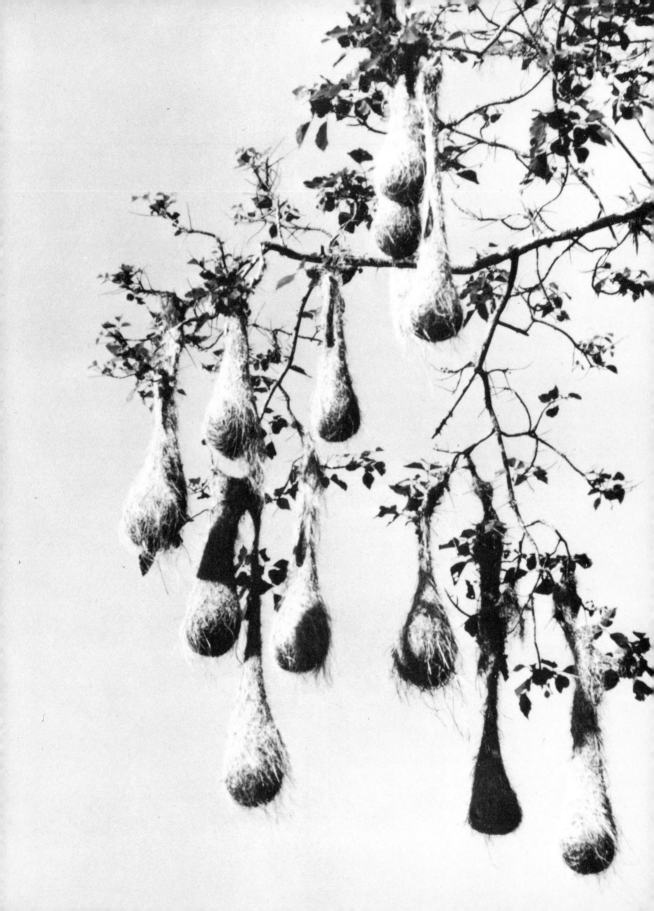

NATURAL LIVING SPACES

Their Delicate Tenement

The nest, although formed nearly in the same manner as several others . . . was fixed to the body of the tree, and that of a branch coming off at a very acute angle. The birds were engaged in constructing it during eight days, working chiefly in the morning and evening. . . . One morning I observed both of them at work; they had already attached some slender blades of grass to the knots on the branch and the bark of the trunk, and had given them a circular disposition. They continued working downwards and outwards, until the structure exhibited the form of their delicate tenement.

John James Audubon, *Ornithological Biography*, Vol. II

Man, from his earthbound position, has long been fascinated by the antics of birds—their easy chandelles in the air, their seeming joy, and the amazing intricacies of the nests they fabricate. From before the time Noah watched the dove return with the greening sprig, birds have been carefully studied to learn where the ripe fruits were, where danger lurked, where a school of herring teemed just below the surface of the sea, or where there was an easier trail through rugged mountains. Icarus made feathered wings but flew too near the sun. Today gliders float silently like soaring eagles, and the more adventuresome build man-carrying kites with delta-shaped wings and simple controls that imitate the flex and yaw of avian muscles.

Many wild creatures have been seen to play—otters' winter sliding parties on snowy riverbanks, a vixen rolling her kits over and over in the dry August grass, a group of chickadees hopscotching on pine branches, or skylarks in "endless exultation," almost never still, rising into the continuing rapture of their song and "clinging to the sky with trembling wings." This play activity, according to Joseph Wood Krutch, demonstrates the use of energy above and beyond that necessary for just keeping alive. "It is joy . . . which inspires the antics," Krutch

75

Nests of the crested oropendola, Trinidad. Photograph by Maitland A. Edey.

observes in *The Great Chain of Life*. N. J. Berrill once wrote that "To be a bird is to be alive more intensely than any other living creature, man included. . . . they live in a world that is always the present, mostly full of joy."

Many creative writers have stressed the feeling that the generous outpouring of bird sounds that delight us are more evidence of their joy in the present moment. In *Driftwood Valley*, which describes in hauntingly beautiful prose the wildlife of the northern interior of British Columbia, Theodora Stanwell-Fletcher speaks of a whole congregation of small birds:

> Willows and alders are alive with the flashes of color of dozens of warblers. Audubon's are the most common; such little beauties with yellow throats and topknots, blue-gray and black and white bodies. Redstarts, orange and black, northern pileolated, bright yellow with black caps, yellow warblers, canary bodies and breasts streaked with pink-brown, decorate the bushes like colored necklaces. They are never still a second. Ruby-crowned, as well as golden-crowned, kinglets hang every dark green spruce with chains of bubbling, rippling melody.

They are creatures of joy with a frail structure that can still ride the storm wind, but when it comes to nest building they are artists, engineers, and sculptors in equal measure. Some do not fabricate a structure but use what is available. A bank swallow enlarges a fissure in an easily carved sandstone cliff, a sapsucker enlarges an insect boring to wiggle in a dead alder branch, or a flicker pecks out the soft pulp of the giant saguaro between ribs like the rods in reinforced concrete, making a space where he can get inside and out of the withering sun. But even in instances like these, where a bird pre-empts a place, he furnishes it with love—and care. In *Arizona and Its Bird Life* ornithologist Herbert Brandt describes a nest he found sixteen inches down inside a saguaro. It was lined with "warm fur, mainly cow and badger hair, but there was also one whole rabbit's tail; and all were so matted together that they formed a felted quilt. . . ."

All nests are marvels, really, but perhaps first consideration should be given to the smallest miracle, the hummingbird's walnut-sized cradle—described by Alexander Wetmore as "a thimble of sage leaves."[1] Brandt tells of one fashioned by the blue-throated species that contained fifteen hundred miles of spider silk and insect thread.

Imagine the nest of the ruby-throat as described by Donald Culross Peattie in *A Cup of Sky*:

> Externally the nest of the ruby-throat is perfectly camouflaged with lichens. . . . Within, the minute cradle is lined with thistledown, milkweed silk, the "wool" from the leaves of sycamores, or the stems of young cinnamon ferns. And the whole is saddled firmly on the twig with bits of spider silk woven by the needle-like bill of the female as cleverly as by any seamstress.

When the nest is finished the female goes on decorating the exterior with lichens long after the eggs are laid. Some nests are inverted cones hung with

ribbons of vegetation, with lumps of dirt woven into the bottom web to counter-balance the weight of the bird. Crawford H. Greenewalt, author of a handsome book of photographs called *Hummingbirds*, tells of a very beautiful nest suspended from the tips of two fern fronds and decorated with snippets of lichen and tiny curled leaves.

Walter Scheithauer, writing on the same subject, tells of a Brown Inca hummingbird who built a deep funnel by catching cobwebs drifting in the wind. It placed these crosswise on a branch, then picked up the loose ends and coiled them clockwise around the branch. Sometimes it used its bill like a darning needle, flying around and around and sticking in the loose ends. Moving inside, the bird used its feet to bend the edges upward, and its neck, bill, throat, and wings to form the interior into a hemisphere. Raising the nest edge to draw the material up over its head, the tiny bird first formed an arch and finally a complete roof. Mr. Scheithauer tells of another nest he found that was shaped like a pouch-type purse decorated with festoons of grass. Quoting Alfred Edmund Brehm, he speaks, with affection, of "their visible enjoyment of life."

Brief mention has been made of the decorative accents on hummingbird nests—streamers of grass and spider silk, lichen scraps, and curled leaves. But many other species also add fanciful touches. The martins may use crayfish claws. The Bullock's oriole was seen to add all around the rim a graceful fringe of seed heads of wild oats. The great crested flycatcher may weave in the castoff skin of a snake to intimidate robbers, or, failing to find a snakeskin, may use instead bits of shiny cellophane or aluminum foil. The Arcadian flycatcher anchors and secures its structure with insect silk and lets these shiny threads stream down from the edge.

The yellow-throated vireos may decorate with the silk egg cases of spiders suspended by a strand of the silk. The blue-headed vireo was observed in 1887 to use, for extra trimming, "The spiders' cocoons, the inner bark of hemlock and the pale-gold sheeny outer bark of the yellow birch." Writing in *The Auk* in October 1903, William Brewster described a Philadelphia vireo's nest:

> The exterior is beautifully decorated with strips of the thin outer bark of the paper birch, intermingled with a few cottony seed tufts of some native willow still bearing the dehiscent capsules. Most of these materials are firmly held in place by a gossamer-like overwrapping of gray-green shreds of *Usnea*, but here and there a tuft of willow down or a piece of curled or twisted snow-white bark was left free to flutter in every passing breeze. It would be difficult to imagine anything in the way of external covering for a bird's nest more artistically appropriate and effective.

The structure of the nest itself differs greatly with different species, but consider just a few. The yellow-headed blackbirds in the swamp use strands of soft water-soaked grass to weave and wind around the reed stems. When it dries, the grass contracts and shrinks to form a tight, compact basket. It may be lined with leaves and the rim decorated with fruiting tops of weeds. The rusty blackbird may form a hollow bowl of duff lined with coiled rootlets. The hooded orioles of the

Southwest may actually sew their nests together by piercing or drilling holes in a palm leaf with their beaks and inserting palm fiber or yucca "threads" through the holes to stitch together a home. An Alta Mira Lichtenstein's oriole built a nest that was twenty-five inches long. The well-tucked-in rootlets used for weft numbered 250. Other rootlets, twisted tightly around the edge, gave a rope-like appearance.

The orioles have been recognized master nest architects for a long time. Baltimore orioles, with what Audubon called their "astonishing sagacity," were observed working, upside down, in pairs. The bird on the outside pulled a fiber out as the female on the inside, with shuttlelike movements of the bill (as many as 100 at one visit!) pushed it through. The random stitching produced a chaotic mass of fibers tightly looped and knotted together.

The deep woven pouches of the orioles sway in the wind on the tips of terminal elm branches, but there are other woven pouches too. The vireos build pensile nests, and so do the verdins, the bushtits, and the dippers. John Muir called the dipper's nest one of the most extraordinary. It is a hollow globe woven of moss and grass about a foot in diameter with an arched entrance at one side.

A newcomer to the Southwest is the rose-throated becard, who builds a huge airy castle shaped like a pear or a teardrop. One observed in Guadalupe Canyon, Arizona, measured two feet long and three feet in circumference and was loosely woven of dried grass and stems of plants with inner bark strips and long feathers.

The ubiquitous weaverbird family of Africa is a group of master weavers. Their lace-like bowls with long, transparent sleeve entrances pointing downward are sometimes constructed very close to the ground so an observer can see into the intricate structure. That of a slender-billed weaver resembles a fine latticework of elephant grass and strips of palm that the weaverbird foraged by biting the palm leaf and tearing down the length of a blade. Some of these expert weavers add canopied entrances or balconies and finish off the edges of an opening by tucking all the loose ends firmly in place so that a selvage edge is formed.

The nests birds fabricate fascinate and delight us. They are shallow or deep, coarse or fine, rough or smooth, pensile or flat, dense or so nearly transparent that the eggs can be seen inside, but they are all wonders—as are the birds themselves. As Henry Beston says of animals, "In a world older and more complete than ours they move finished and complete, gifted with extensions of the senses we have lost or never attained, living by voices we shall never hear." They move in and out of our consciousness like lighthouse beams that wink on and off at different intervals. At day's end most nests are filled with a pulsing, feathered presence and, like Edna St. Vincent Millay, we hear, "Whip-poor-wills wake and cry,/ Drawing the twilight close about their throats."[2]

Hurt Not the Earth, stitchery with trapunto on white linen by Grace O. Martin.

Bird and nest fabricated by Pamela Plummer in techniques that predate the loom.

Natural materials nestled among stuffed shapes on a fabric surface embossed with relief stitches in *Earth Home* by Margaret Boschetti.

Spider web. Batik by Martha Brownscombe dyed
with iron-rust and potassium permanganate.

The Aeronauts

On St. Herbert's Island, I saw a large spider with most beautiful legs, floating in the air on his back by a single thread which he was spinning out, and still, as he spun, heaving on the air, as if the air beneath was a pavement elastic to his strokes. From the top of a very high tree he had spun his line; at length reached the bottom, tied his thread round a piece of grass, and reascended to spin another—a net to hang, as a fisherman's sea-net hangs, in the sun and wind to dry.

Samuel Taylor Coleridge, *Anima Poetae*

Man has long been fascinated by the arachnids, spinners of silk, which construct webs and weave egg cases and traps, cunningly contrived out of fine, strong filaments, and then float off into the unknown on a silk thread of their own extrusion, sailing away on the magic carpet of an updraft of air.

In the warm sun of late August many juvenile aeronauts will climb to the top of a weed, spin a thread, and then wait for a breeze on which to cast off. Robert P. Tristram Coffin, in "Oldest Airman," says, "The sail is much too thin to see,/Moonbeams are coarser napery." Sometimes the current of air stops suddenly, and with it the thousands of floating strands slowly settle and may even carpet a whole field with the fine shower of silk that is called gossamer. Some say that the word came from "gauze of Mary" because this floating silk was identified as being part of the winding-sheet of Mary.

It was always a puzzle to know just where the silk came from. Spenser spoke of it as "the fine nets which oft we woven see/of scorchèd dew." We know now that they are not fabricated from dew but exuded from the spinnerets in the spider's abdomen. Gossamer webs have been seen at great heights, such as the pinnacles of the York Minister Cathedral; every year on the sides of Yosemite Valley there is a reoccurrence of gossamer covering quite an area. It is the old pattern of the young of any species or any culture leaving home and launching out into the unfamiliar, the unexplored.

Man has long been fascinated by the handsome fibers of great delicacy that insects fashion. Marston Bates, describing in *Land and Wildlife in South America*, the bell moths of South America tells us that "When the larvae hatch, they crawl over the needle-sharp stakes on a silken pathway which they spin themselves." With apparent ease the spiders exude filaments that, if they were of manmade nylon, would require over 500 degrees F. of heat and thousands of pounds of pressure during the drawing-out process. Many attempts have been made to

83

start a spider silk "farm" to raise commercially this fiber that is stronger than silk, with little success. "The Spider" of Robert P. Tristram Coffin describes it:

> *With six small diamonds for his eyes*
> *He walks upon the Summer skies,*
> *Drawing from his silken blouse*
> *The lacework of his dwelling house.*

The webs the spiders fabricate are based on several general types. There is an irregular net that is like a maze of lines extending in all directions. Some of these are like sheets of webbing closely woven in a single plane. Sometimes sheet webs are shaped into funnels with a closed tube leading to the spider's retreat, and some, as *Agelena naevia*, build an irregular net above the funnel, which causes the insect victim to fall into a down-sloping corridor from which he cannot return.

The beautiful geometric exercise that we all see and recognize is the orb web. These webs are often very large in diameter and may have from thirty to forty radii of dry inelastic silk connecting the concentric rings. The center hub may be almost completely filled, or it may be open, but surrounding this central area and forming the greater part of the orb is a line of viscid thread laid down in a spiral. This is elastic and sticky and is composed of two strands: a smooth axis and another filament carrying a series of globular drops of viscid liquid-like catenaries, beads on a silver cord. Spenser spoke of them as "liquid pearls which they serve to string." It is this viscid elastic silk that stretches to surround and hold the intruder in the silken trap. One species, *Hentzia basilica*, spins a complete orb and then pulls the whole into a dome-shaped structure. Another type of domed orb is made by the water spider, *Argyroneta*. These spiders spin in the water a cell of strong, closely woven white silk, in the form of a diving bell— about the size of a small acorn. It is anchored to some near object and is closed all around but has an opening below like an inverted cup. The bell shape holds trapped air bubbles that the spider carries down between his legs, and the spider can then live part of his life underwater. Another, the *Hydropsyche* or "water sprite," makes a snare formed like a dip net with silk fastened to a frame of leaves.

Silk from their spinnerets is used to make geometric forms in silk, but it is also used to cushion the spiders' eggs and line their nests. One author writes that they "tie their treasure up in silken bags." Sometimes a group of eggs is enclosed in a woven envelope which may be opaque or translucent—a silken egg purse. In others half the structure is made, the eggs laid, and then a concave cover is added to complete the silken cup. These are usually globular and may be white, yellow, or blue-green. Some eggs are placed in a fluffy mass of silk; others are double-wrapped with a closely woven outer layer of brown silk. Some are spherical, some pear-shaped, and one, *Argyrodes trigonum*, is formed like a Grecian vase. Some spiders envelop the egg sac in a silk net and suspend it over a cliff edge by a stronger cord, or from a tree, like that in Theodore Roethke's "Slow Season":

The garden spider weaves a silken pear
To keep inclement weather from its young.
Straight from the oak, the gossamer is hung.

All these structures are wonderful to see, but J. H. Fabre in *The Life of the Spider* has a favorite:

> The most remarkable in my district is the Banded Epeira. . . . Her nest, a marvel of gracefulness, is a satin bag, shaped like a tiny pear. Its neck ends in a concave mouthpiece closed with a lid, also of satin. Brown ribbons, in fanciful meridian waves, adorn the object from pole to pole.

These delicate structures, designed to cushion the eggs, trap the food, keep out enemies, or serve as a communal or nursery tent to protect the young, are constructed without knots. The thread sticks by its own glue or is anchored to a grouping of fine threads called an attachment disk. Though some of the webs appear circular, they are all made of nothing but straight lines and combinations of them. Examine all you find and you will thrill to their beauty. What spinners! What weavers!

> There is everywhere dew on the cobwebs, little gossamer veils or scarfs as big as your hand, dropped from fairy shoulders that danced on the grass the past night. Even where the grass was cut yesterday . . . dewy webs are as thick as anywhere, promising a fair day.[3]

Raw-silk webs spun on a pear branch by Judith Gorski.

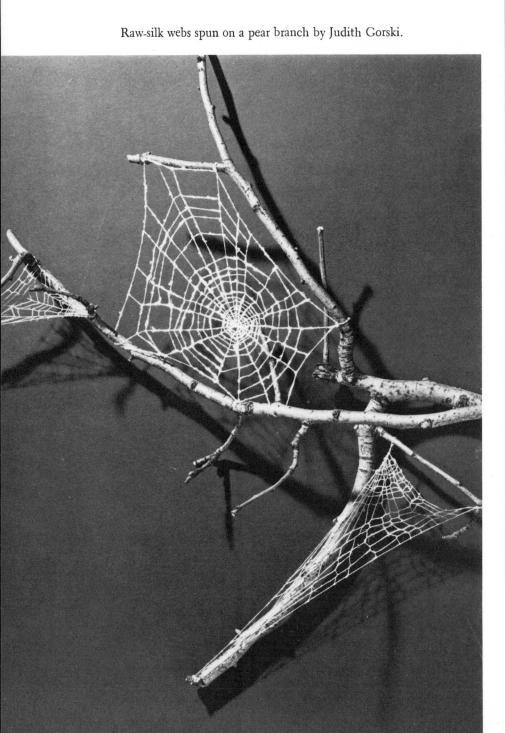

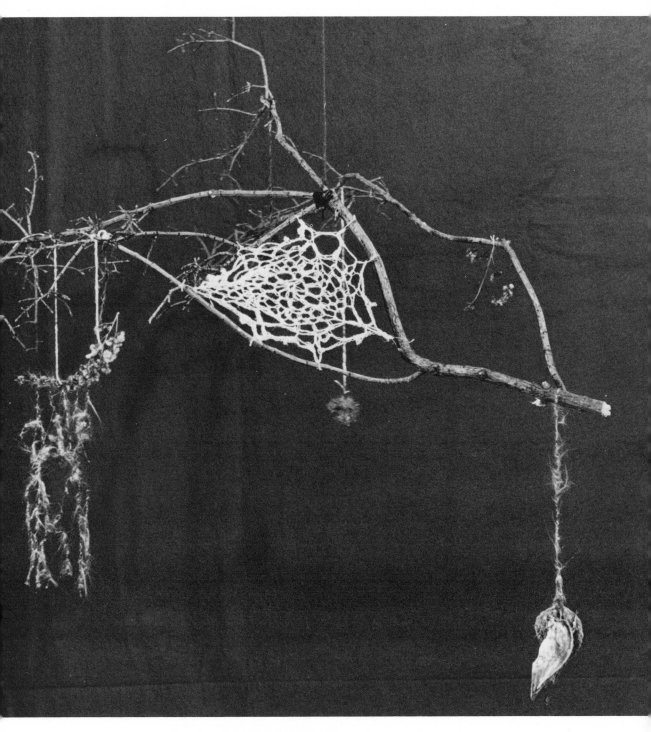

Twining with free-form crochet by Susan C. Bro.

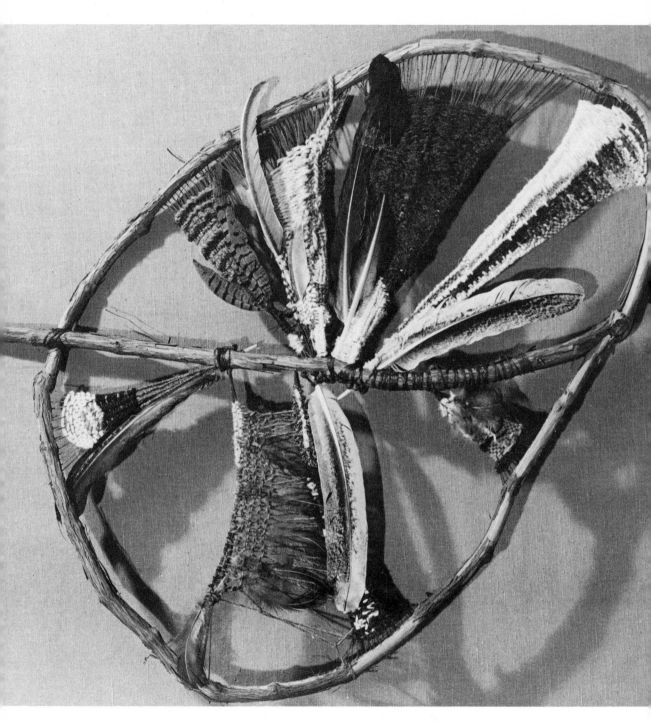

A found loom of coiled wild grapevine holds a needle-woven design of fibers and feathers by Sue Boyer.

The Composite Loom

Pre-literate man was aware of his environment in a very real sense. To survive he had to observe general forms and precise detail and mentally record what he saw so he could use this information at a later time. His primary consideration for survival was, of course, food, and many of the very early constructions and the interlacements with fibers that he created were designed specifically for this purpose.

The naturalist-explorer Roy Chapman Andrews once wrote a series of nature vignettes describing some less-familiar aspects of natural history; these were later put into a book called *This Amazing Planet*. In it he describes how natives in parts of New Guinea catch small fish with a dip net made of spiders' silk. "A piece of cane is bent into an oval shape and twisted around and around among large spider webs until three or four layers are stretched across the frame."

Probably the earliest weaving construction was the weir or fish trap. The threading of supple branches or vines in front of and then behind successive stationary elements, such as trees or posts, to create a barrier became the over-one-under-one structure we know as tabby or plain weave. This use of a filling material with some native rigidity made simple the interlacement process. Man learned to use this basic weaving skill horizontally as well as vertically and eventually in the round, using the raffia, reeds, pine needles, and grasses of basketry.

As his skills progressed and his materials and his techniques became more sophisticated, he was able to use them to secure clothing and shelter as well as to gather food. He learned to produce softer fibers by pounding, by chewing, and by spinning fragments into a long soft yarn, and when he had achieved this, he had a flexible, infinite line that could be manipulated into exciting structural forms.

He taught himself the whole gamut of fiber interlacements in which a structure can be fabricated from a single, continuous line. These included knotting, braiding, plaiting, twining, looping, knitting, crocheting, tatting, wrapping, twilling, or any combination of the above. He first learned how to build a form and then how to add decorative touches of color, detail, or whimsy that went beyond the function of the piece.

Rachel Carson's poignant picture of a woven happening on a deserted stretch of beach contrasts sharply with the woven hangings in today's fiber shows that are crudely imitative of nature. Too often they are huge masses of threads and cords, rough with rust-encrusted iron and tarred rope, that require an armature to maintain the form—a far cry from her description in *The Edge of the Sea*:

A thin net of flotsam is spread over the beaches—the driftage of ocean brought to rest on the shore. It is a fabric of strange composition, woven with tireless energy by wind and wave and tide. The supply of materials

89

is endless. Caught in the strands of dried beach grass and seaweeds there are crab claws and bits of sponge, scarred and broken mollusk shells, old spars crusted with sea growths, the bones of fishes, the feathers of birds. The weavers use the materials at hand, and the design of the net changes from north to south.

But man was first of all an observer. All these fiber and fabric developments had their beginnings in his awareness of his surroundings. Birds showed him how to find seeds and grains and how to pick the ripest fruits. He watched them at their nest building and saw a compact concave structure rise from the triangular intersection of a forked branch. Pieces of grass and bark were woven over and under and through the limb, and the branch and the nest became one unit, inseparable. If the branch was removed, the nest collapsed into a jackstraw heap of disconnected twigs.

Spiders were also great teachers of pre-literate man. He saw them exude the silky filament and connect it at intervals to form delicate webs. He saw and felt the lace-like structure as it ripped against his face when he crawled into a cave. Now the silky threads bore little resemblance to the tensioned web that had been built into another structure, the cave mouth, depending on the rock for its own form. Here was another composite or unitary structure. The web was not a web without the sides of the cave opening to hold taut the strands and maintain the woven form.

Sigurd Olson, who in poetic prose so graphically paints the northern scene, describes how a Chippewa woman might make a spider-like web to hang above her sleeping child, a dream net formed of fine threads strung on a small hoop of ash with a very small opening at its center. The idea was that good dreams could come through the hole, but frightening ones would be tangled in the net, unable to escape and disturb the sleep of her papoose.

Spiders and many other natural weavers gave man ideas. The airy gauze apartments of the tent caterpillars may have shown man how to make a shelter by wrapping a basic architectural form with individual cords or threads darned together to make a fabric. When he destroyed the caterpillar's nest by trying to lift it from the branch, he destroyed the structure. It didn't and couldn't exist as a form without the forked branch to shape it. Man adopted this idea himself and made a tent by wrapping skins or cloth woven of beaten bark around an apex of upright sticks or poles to form a conical living space. When he removed the poles, he obliterated the form. To make a tent or wigwam he needed the composite cone formed of both branches and skins.

In the Empty Quarter of southern Arabia the tent is formed of black goat-hair panels that have been previously woven, horizontally, on the ground by the Bedouin women. Supported by poles and guy ropes, the panels become a shelter to keep out the ubiquitous sand and the searing simoom. When moving is necessary, the woven cloths are simply wrapped around the poles, tied with the ropes, to be unrolled and set up again at the next living site.

Far to the north another nomadic people, the Lapps, make a *kota* or tepee of

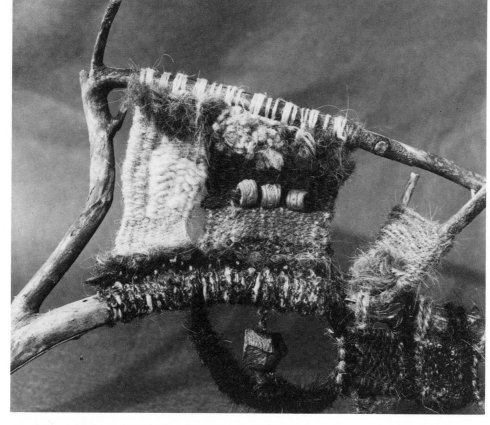

Pre-loom construction featuring the textures of horsehair, bisque beads, nuts, and collie hair by Susan Weimer Tassi.

saplings wrapped with colorful wool and reindeer-hair rugs, the weft-face *raanus*, to keep out the windrift of snow and the chilling winds off the *vidda*, the plateau at the edge of the tundra.

While tracing the early beginnings of man's experiments with fibers, one finds that when he progressed from using stiff, rigid materials to those softer and more flexible he had to search continually for ways to tension these elements to make them easier to interlace.

He tied stones to weight each separate warp end, to make them all taut individually, or tied all of them to a log to make them tight collectively. If no log or branch was available, he knotted all the warp ends to his own body to secure tension. As he increased the number and density of the warp ends, he was forced to invent the simple loom—a tool that is basically a warp-tensioning device.

Although the loom was contrived thousands of years ago, in a pre-ceramic age, it remains essentially the same today. Paul Rodier, in *The Romance of French Weaving*, wrote many years ago:

> Through all the ages the path of the weaver has been the path of true civilisation . . . And there where a loom is waiting the night of savagery is over.

Birch branch shaped like a mandolin. A chained weft and catkins grow out of the camel's-hair warp. Construction by Barbara Hoopingarner.

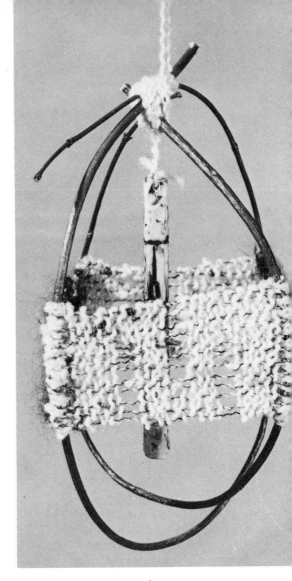

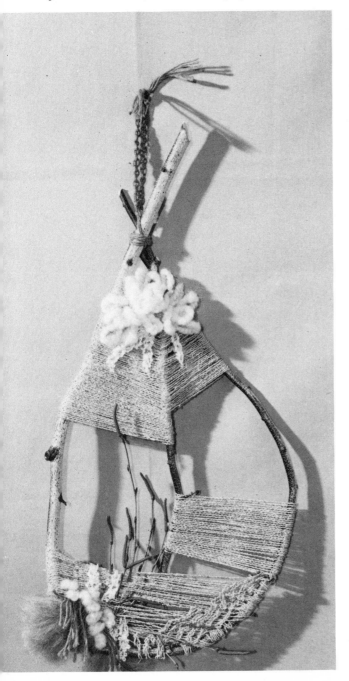

Two intersected hoops of raspberry cane form a four-sided warp for Gwendolyn K. Veil's weaving.

A harp of mohair and swamp fern seedheads
woven on a birch sapling by Leah B. Hoopfer.

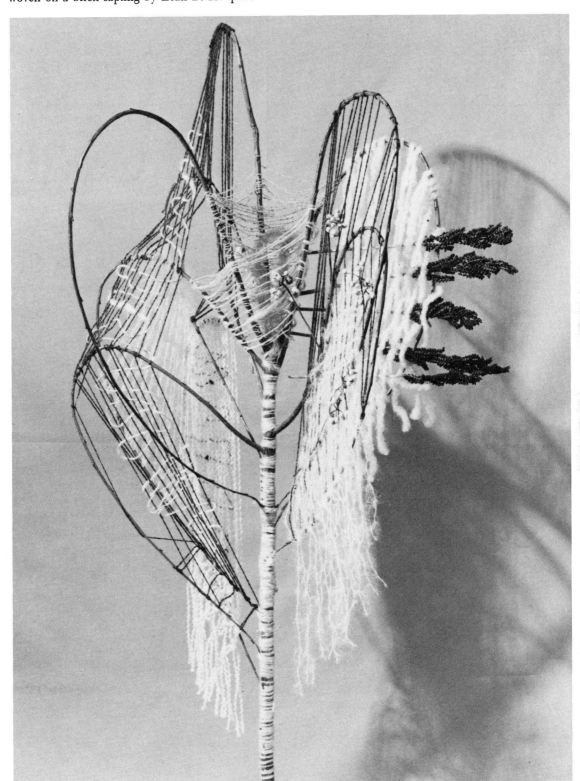

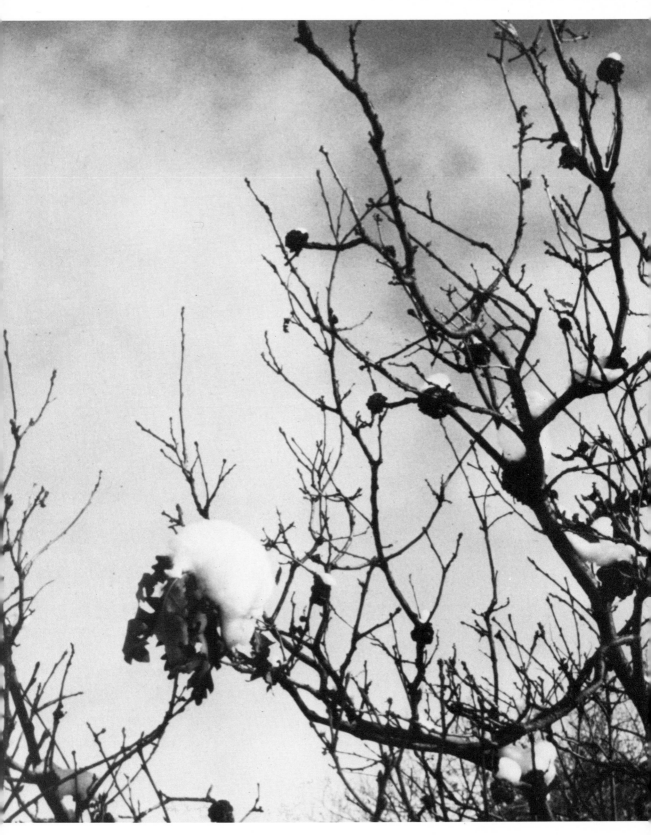

Pine branches etched against a Colorado sky. The rough globes
are caused by gall invaders. Photograph by E. C. Martin.

The Galls

A gall is the fruite of an oke, and especially of the lefe—1562.[4]

The word "gall" can be used as an adjective, a verb, or a noun, but the connotation in any case refers to a bitter flavor, an annoyance or harassment, or a botanical response to an irritating invasion. The reaction of the plant host to the parasitic invader is increased cellular activity and often an increase in the size of individual cells, either or both of which may result in the formation of strange and awesome structures. Galls are found on all major classes of plants and on all parts of a plant. There are leaf galls, stem and bud galls, root and flower galls, and even galls on top of other galls.

The gall makers are a large and diverse group. There are mites, midges, aphids, beetles, wasps, flies, and some bacteria and fungi as well. The insect-caused growths are often nursery chambers for the developing larvae, and these free-form living spaces are really amazing structures. A craftsman working with textiles should look at these three-dimensional forms.

The smallest, perhaps, is the jumping gall of the Oregon oaks (Quercus garryanna) that forms on the underside of white oak leaves. Inside the tiny sphere, the size of a mustard seed, the active movement of the larva strips it from the leaf, and dozens of them fall to earth and collect in hollows and gutters under the trees where they can be observed "jumping" like miniature bouncing balls.

Oak trees seem to be very attractive to gall-producing insects; in Great Britain alone more than forty different types are found on oaks. One of the largest oak galls forms pouches, balls, or boxing-glove shapes that are the color of parchment and as hard as wood. They are lightweight, fiber-lined hollows, and the interior may be single-chambered or multichambered. The common oak-apple variety is a sand-colored sphere usually the size and weight of a Ping-pong ball. In the Middle Ages these strange, unnatural protuberances were used to foretell coming events. If a maggot was found when the oak apple was opened, it meant that the coming year would bring famine. If instead of a maggot a fly was present, war or want was foretold, and if a spider was found, it was thought to be a harbinger of pestilence or death.

Perhaps because so many varieties of galls are found on oak trees, these are the best-known and most recognized. One of them, the Aleppo, has had the longest commercial use. Found on oaks in Eastern Europe and Western Asia, it is hard and spherical and may contain as much as 65 percent tannic acid. From these oak marbles a black dye was produced for coloring wood and human hair, for tattooing, and to make a very black ink. Because of its permanency Aleppo ink was at one time the only ink accepted for use by the Bank of England and the United States Treasury.

Many other oak galls are of interest to the designer of three-dimensional space. The spindle type consists of small ovoids terminating in points that are topped with a crown of brown or white "wool." The currant gall looks like its namesake—a string of small red beads on a slender stem. The hedgehog and horned types are covered with spiny protrusions like the points found on a sweet-gum ball or on a sea urchin. A similar type, on witch hazel, is like an olive with spikes. There is another gall maker that causes an oak leaf under attack to form translucent pale-green balls like frosted glass. When the sun shines through the flexible walls, the spheres appear to glow, mysteriously.

Many galls are fibrous. Some appear to be upholstered in felt or suede. A small silk-covered one growing in colonies on the underside of leaves has the imaginative name of silk button spangle. Some hollow galls have silk-lined cavities, and some have a hairy fringe like whiskers around the top or crown of an acorn.

Perhaps the most dramatic gall structure and also the most fibrous is the bedeguar or moss gall found on roses. This unusual natural phenomenon has been called "Robin's pin cushion," and it may grow as large as ten centimeters in diameter. Its multichambered structure covered with dense moss-like threads or branching hairs changes through the summer months from pink to crimson to brown and finally to a dry cluster of empty larval chambers. There may be as many as sixty cell-like rooms in one bedeguar. Years ago these mossy balls were collected and burned in lamps instead of oil.

Another natural ball of yarn of interest to fiber craftsmen is the plant reaction caused by the insect *Callirhytis seminator*. Ephraim Felt, in his great source book *Plant Galls and Gall Makers*, describes the delicate structure: "The fresh, well-developed, creamy-white, pink spotted gall of the wool sower is one of the most beautiful of natural objects." It is a white-pink woolly growth, spherical in shape, and those that appear on the bald cypress trees are said to be flower-like.

When a plant is attacked on its buds or its flowers, there is a great flurry of plant growth and the rapid proliferation of petals or leaves or needles or twigs. The result is often a crowded unusual layering named after other vegetable layerings—such as cabbage or artichoke galls. On scrub willows some resemble dried roses formed by a cluster of petals cut out of silver-gray cloth. The multiplication of twigs growing out of the forked branches of trees causes bizarre tangles called witches'-broom. These tight, crowded growths are sometimes selected as safe nesting sites by birds, and the whole tree becomes a noisy condominium. The work of galls may be as devastating to the garden as the effects of war, when

> Her vine, the merry cheerer of the heart,
> Unpruned dies; her hedges even-pleach'd,
> Like prisoners wildly overgrown with hair,
> Put forth disorder'd twigs . . .[5]

Perhaps the gall formation that the largest number of people see both winter and summer is the spindle on the goldenrod. When the flower plumes appear in late July, the gall chambers are bright green bulges on the stem. These may

appear singly or as incomplete pairs. Some weeks later when that same patch of pasture is mocha brown and the weeds and grasses are crisped by frost, the galls on the goldenrod stems stand out in knobby silhouette—small onion shapes like miniature turnings for newel posts or cupolas for a doll-sized mosque. Here and there stands a pale one, beech-bark gray after two Decembers. By midwinter many of these swellings are pocked with ragged holes where birds discovered the larva inside. Intrigued by the smooth elegance of these tapered beads, weavers have used the stems as a rigid weft to capture on their looms in flax or raw silk autumn's stark lines and sepia monotones. The balls themselves have been drilled with holes and used as natural bead accents on macramé fringes. Alice Parrot of Sante Fe has woven them into linen hangings in the bleached straw hues of the arid Southwest.

Fiber craftsmen interested in the three-dimensional aspects of fiber and fabric constructions would be wise to become cecidiologists, or gall collectors. A sketchbook carried on a walk could record an amazing variety of these natural forms, which might range from the curled and folded leaf types, stem and branch swellings, or nodules on roots, to spiral sculptures and textured knots. At home slice some of the collectable forms, examine the inner chambers and linings, and begin to think about interpreting these natural living spaces in fabric or in fiber. In cloth, it would be easy to develop three-dimensional areas with padding and quilting or by raising hummocks or islands, using the Italian technique of organized stuffing called trapunto. With yarn or string or threads, one might crochet raised or filled pockets or cells or buttons, either appliquéd to background material or as part of it—for instance, a cluster of spangle galls on an oak leaf. The weaver could create stem and branch swellings, using a double-weave technique to make seamless tubing. By adding or subtracting warp ends or by tightening or loosening the weft, the weaver could contract or expand the tube. Textured yarns and rug knots, tassels and fringes would recall the mossy-ball type of galls found on roses. The filled forms and whimsical pillows standing on groups of plump legs that Jean Stamsa of Wisconsin creates on her looms could have been inspired by field sketches in a gall collector's notebook.

Once we begin to discover some of these fascinating forms, we are amazed at the wealth of design material they provide. Their colors range from a pale chartreuse to a rich olive in the greens, and from pale yellow to deep orange to brilliant crimson in the reds. One variety, called Apples of Sodom, found near the Dead Sea, is a deep purple-red. In the brown color range, gall structures vary from faun to cinnamon. A few of them are fully developed in just ten days' time, so the same walk on different weeks could be rewarding. Look closely. Look carefully. Remember that some of them are found only by looking up.

Woven sketch of lichen-dyed wools by Heidi J. Bon.
Double-headed concrete nails anchor the warp.

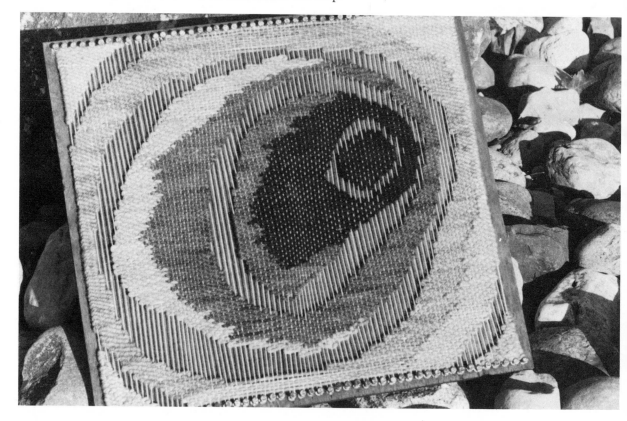

Searching for Shelters

Finger Weaving on Found Looms

In this exercise we are going to search out shelters that were deliberate fabrications —not the turtle's shell into which he can retreat at will, not the flexible armor, the portable fort of the armadillo. We are going to search instead for the fibrous shelters that were created intentionally. The planned shelters of man are made more habitable by adding fibers. We cannot live for long in the stark cube designed by the architect and built by the contractor; we find we must add textile fibers in the form of draperies, carpet, padded seating—just as the titmouse adds a lining of thistledown to the rough basket of intersecting twigs she calls home. Let's look now at some of these natural dwelling places and the fibers or fiber techniques that make them habitable.

98

Lichen-dyed wools woven by Karen Serota on a composite loom made of apple branches and a willow hoop.

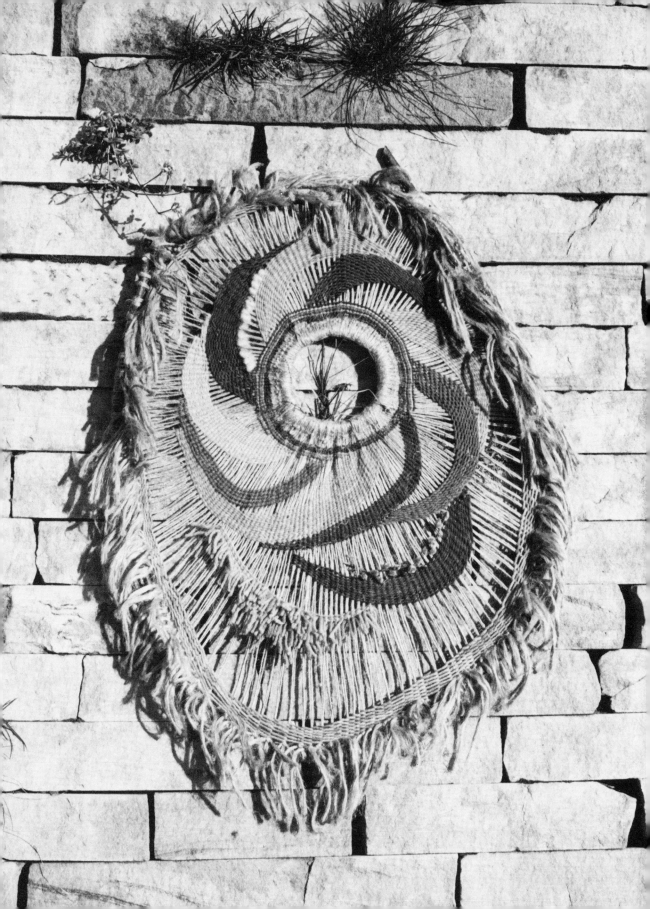

1. Study a nest. Whether the one you find is an oriole's home hung airily on the tip of an arching elm branch or a warbler's fiber egg cup tucked snug in a wolf willow and topped with a dollop of snow, look carefully. Perhaps you will find ribs formed by branches, with finer and more supple material such as grasses or tendrils woven over and under these ribs, or perhaps crossed over themselves between the ribs. Textile artists call this technique twining, and any basketry book will describe several variations of it. Twining makes a tight, compact form and a decorative one as well. How many different fibrous materials can you find in the nest? Is the softer interior just dropped in and shaped by the weight and warmth of the bird's body, or is it woven and interlaced until it has become an intimate part of the structure? Are there any added trimmings—a snip of moss, a curled leaf suspended by a cobweb strand, the dusty wing of a moth? What about the edge of the nest? Is it rough and bristling with twig ends, or is it rounded and smooth with all the twig ends tucked in? How deep is it? Is it saucer-shallow so the anxious parent has a clear view in all directions, or is it deep and dense so only their thin cries betray the nestlings? Examine it only with your eyes or perhaps a pair of binoculars. Do not destroy the nest. If you cannot find a nest outdoors, go to a museum or a zoo, but wherever you look sketch some details in a notebook so you will recall the structures later.

2. Observe a web. Search out dark corners that go undisturbed for long periods of time—the shadowy corners formed in barn beams, or the channels between the floor joists in basement ceilings. Look for the filmy webs that curtain attic windows. Very early some morning look outdoors at small weeds and shrubs. The dew condensed on the webs destroys their camouflage and makes them easy to find. A few hours later this evaporates, making them invisible once more. One species found in northern woods stretches one airy banner just below another, like a safety net to catch a falling aerialist—this time a six-legged one! Look for the transparent nurseries of tent caterpillars or webworms. Any time you find something interesting make a quick sketch in your notebook. If you are lucky enough to find an orb web, examine it carefully. How many radial lines are there? How many attachment points? How close together are the bars between the spokes? Some of the webs will be incomplete or torn. Be sure to sketch these also, because their incompleteness makes them interesting—a bit of verse with the last line missing. Keep searching and recording until you have six or eight sketches in your book.

3. Collect a gall. Tramp through a pasture where goldenrod is starting to show yellow and look at the stems. Chances are that some of them will show green bulges or bead-like forms. At harvesttime these blips on the stems will be turning brown, and in the deep of winter when all the gold is gone these stem galls will be driftwood gray streaked with black. Sometimes two growths run together to make a spherical duplex, or there may be three at intervals along a stem. Look in roadside ditches, along railroad tracks. No one will mind if you collect a few. Often the same wild land will have the thorny whips of floribunda or prairie roses. Look for galls here. There may be bumpy bearded ones, much larger than the

rose hips, made up of small compartments. Find an oak tree. There you may come across parchment-colored oak apples, the size of a Ping-pong ball and just as light. Slice one and find the cotton-candy texture inside. Look at the underside of oak leaves for pea-size galls upholstered in leather-colored suede.

4. Find a loom and warp it. If we define a loom as a warp-tensioning device, then the composite loom can be any form, found or manipulated, that is strong enough to have warp stretched through it and can be made more interesting by the addition of yarns. A driftwood trophy from a beachcombing expedition is an obvious choice. Wind and wave action will have removed any weak parts and left a sturdy form, sand-polished to a fine gray patina. Another possibility is a green branch or fork pruned from a living tree and with some flexible branches that can be bent and lashed to form interesting ellipses. A third choice is to string warp on a large wooden hoop to create a colorful mandala in yarns.

5. To attach the warp, drill small holes along an edge, staggering them to avoid splitting. Study your sketchbook to get some ideas. Look at the spokes of the nest you sketched, the silk spokes of an orb web. Using natural linen or cotton, warp your loom by drawing the thread through a hole on one side to a hole on the opposite side and back again. Keep the warp taut and the tension even. You may want to drill more holes to make a second warp in another plane or at another level.

6. Now that the warp or base structure is in place, think about adding filling yarns. With your fingers or a threaded needle, weave short lengths of yarn over and under and over and under. Push them together and weave some more. Play around with color, but avoid abrupt changes in value or hue. A natural shelter melts into its surroundings. Play around with texture. This is an experiment, so relax and let it happen.

Using your fingers or a crochet hook, try chaining across the warp, loop locked in loop, to make a linked line. If in some areas the warp threads are closer and more numerous, it is possible to weave a tube by weaving over and under the odd threads on the top and over and under the even threads on the bottom. Going in a circular fashion, you will soon find that you are making a double layer or pocket that can be stuffed with quilt batting. Study all the gall forms you sketched. After you have stuffed the pocket, the pillowed area can easily be closed by weaving over and under all the warp ends. Think about adding some soft touches to your composite loom—soft touches like the lining of a nest, the woolly "fur" of rose galls, the woven silk pouches of spider mothers. Try adding brushed yarns spun out of mohair, clinging ones reeled from silk cocoons, shiny rayon ones pulled through spinnerets, and knotted tufts like the velvet wool of an old prayer rug.

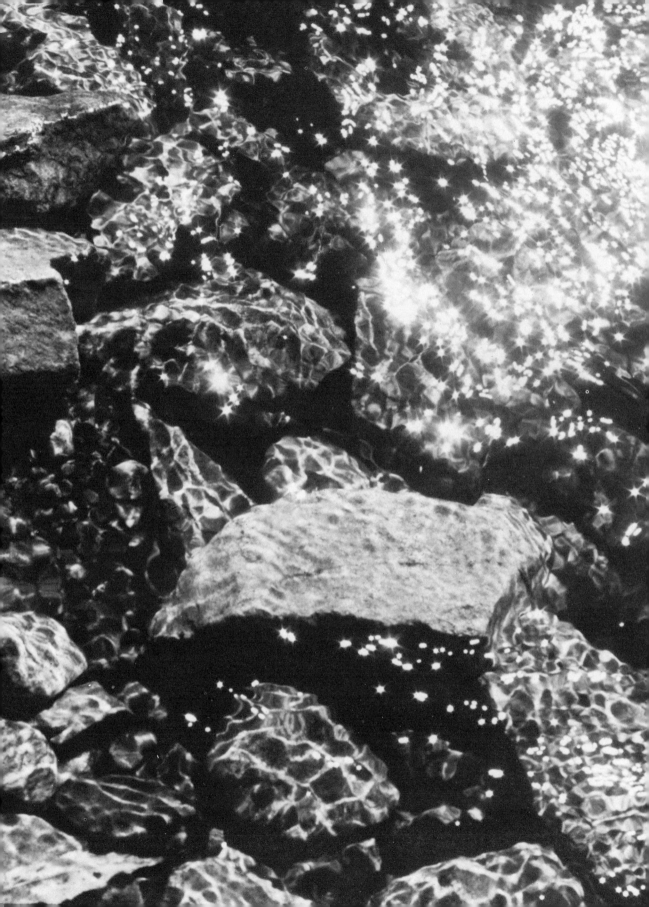

NATURAL MOSAICS

A mosaic is a fragmentation. The different color areas of a mosaic design are made up of many small parts. This allows for subtle or jarring color differences in the individual pieces, and it is this variation that makes a mosaic muted and soft or bright and hard, reflecting light like a faceted stone—brilliant, jewel-like, pulsating. One author defines this quality of a mosaic as "active color in organized planes." Colors move and change with every shift of the viewer's stance, because the hard, mirror-like reflecting surface of the glazed tiles, or the cubes of translucent glass called smalti, reflect and refract light.

Ancient mosaics were also made brilliant by the use of smalti imbedded with gold leaf, opalescent nuggets of abalone shell, small mirror fragments, and rounded shards of blown glass.

The more subdued of the classical mosaics resembled paintings. Skilled craftsmen produced dozens of red tesserae, for instance, and the almost imperceptible differences in value, intensity, and texture allowed them to put tiles down as an artist lays down brushstrokes, moving ever so slightly to dark or light, soft or bright, to make the cheek round or the throat recede from the chin.

The brilliant mosaics, however, moved boldly from one tile to another one jarringly different—from a strong red to a grayed pink, or from a light red to a crashing orange. Now the mosaicist was working as a pointillist painter with clear, strong spots of color rather than with strokes lapping each other.

Another reason for the effect of throbbing light is the strong contrast of color. Looking at the spectrum bent around into a wheel, one sees directly opposite a hue its complement. It is the color most diametrically opposed but also the one needed to bring out or complement, if you will, the strongest characteristics of the first hue. The ancients knew that to make a red-orange appear like a flame, they would need close by some blue-green—its opposite on the rim of the color circumference. A cluster of cadmium-yellow lilies would be given blue-purple shadows to make the yellow sing. Thoreau, with his great gift of seeing, uses strong contrast to capture the mood of late summer: "The thistle scatters its down on the pool, and yellow leaves clothe the vine, and naught disturbs the serious life of men." The weightless silk of the down contrasted with the sharp stab of the thistle's thorns, the implied purple of the flower with its complement of yellow leaves.

103

Reflections make underwater traceries on the rocks as the sun glints on the surface of a cold canyon stream. Photograph by Margaret Boschetti.

In the Dakota Badlands the whole landscape is hot and dry with impressive stone pinnacles and arches of striated rust and tawny gold. Dramatized by the purple shadows of early evening, the complement of the warm ocher of the rock, the effect is even more startling, for here, as Loren Eiseley says in *The Immense Journey*, there is "no shade except under great toadstools of sandstone whose bases have been eaten to the shape of wine glasses by the wind."

In the cool woods of the Far North we find living mosaics, kaleidoscopes of color lighting up the dark pools of shade under the conifers like the contents of a spilled button box. Imagine those described by Theodora Stanwell-Fletcher in *Driftwood Valley*:

> And every stream waters a flower garden of surpassing beauty. . . . Masses of low Epilobiums turn the banks rose-pink. Great clusters of purple monkshood and lupines and white saxifrage and starflowers cover the flat places. Giant blue forget-me-nots, wet all day by cold spray, lean over into the water. Purple bluebells and gentians, scarlet columbines, and star-white grass-of-Parnassus stud the rocky outcrops. Buttercups and yellow daisies light the shadowy places like sunshine.

Virginia Eifert in *Journeys in Green Places* describes a cool northern ground cover as having this same type of fragmented design:

> The carpet often tends to form a mosaic of its closely-set plants. The mosaic may be composed of the shamrocks of the white oxalis, of rose moss and sphagnum whorls or of the medallions of bunchberry . . . leaves on short stems bearing in the center of each a miniature white dogwood flower. In August this is replaced by a fine boutonniere of scarlet fruits.

The mosaics of nature are everywhere. Subtle or startling, they delight the eye and invite exploration. Behind a boulder at the edge of the surf, where the scree has collected in a hollow, lie wooden pebbles shaped by the waves, the cupped spoons of periwinkle shells lined with wet blue purple—the coral of a crab's claw, the oval of a smooth stone embroidered with rows of barnacles in oyster-white.

In every vacant lot, in spilled earth that man has dropped or in places not yet smothered with asphalt, green mosaics are constantly forming in myriads of shapes and many sizes of leaves and stems and buds and blossoms. Blue chicory with quarter-size rosettes cut out of blue sky, notched at the edges, are attached at random to stiff angular stems. The rippled ribbon leaves of curly dock rustle below the dry coffee grounds of its seeds, and povertyweed rusts in the sun.

In the pasture the yellow-orange of brown-eyed Susans and Coffin's "Sunflowers," "The dials of these honeyed clocks/Fringed with leaves of sun," are made more brilliant by their spiky neighbors of blue vervain whose reaching fingers are studded with florets of purple, aging to mauve. The pasture floor is a gray-green one with scarlet caps on upright fingers—a lichen dubbed "British Soldiers" long ago. Strong contrasts of color make each hue vibrate: saffron and purple,

104

Transparent leaf forms in varying shades made from one color of ink mixed in various amounts of base. Stenciled design by Jacqualine McLemore.

orange and teal, scarlet and green. Pastures aglow with the finale of summer are dramatized by frost. Malcolm Cowley paints the scene in "The Red Branch":

> *Sky after sky of windless blue;*
> *warm days, but with a secret chill.*
> *The forest wall is green except*
> *for one red branch on the hill.*

The mosaics of the early pioneers were made of earth colors. The cabin rafters were studded with bunches of silvery sage leaves, red-purple onions with their tops braided together, dried apple slices strung on a string through holes made by a corer. In the loft there were sacks of strawberry corn for popping, butternuts for cracking, soft mounds of carded wool for spinning, and skeins of gold and orange and cinnamon, chained and ready for the loom.

In the back bedroom under the shed roof glowed the patchwork quilt, a scintillating mosaic of color and texture. Small pieces of cotton and silk, patterned and plain, bright and dull, striped and sprigged and dotted, were arranged in prim patterns called "Rebecca's Fancy" or "Double Wedding Ring" or "Dresden Plate"—small pieces of past joys stitched down with love.

Flowering branch complete with butterfly. Silk screen, trapunto, and stitchery by Janine Watters.

Jack C. Houston made shadow stripes by stenciling across a spaced series of narrow strips of gummed tape. Additional stenciling and stuffing suggest natural forms.

Flower form dramatized on white velveteen. Silk screen with hand-stenciled details. Stuffing and stitching add texture. An original by Krista Washam.

Stylized pasture forms: teasel, clover, and
awned barley, hand-stenciled by Vivian Hoxsey.

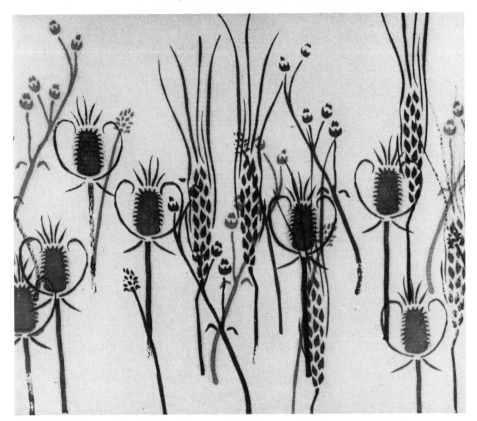

Discovering Patchwork Patterns
Ideas for Appliqué and Trapunto

Nature's mosaics are everywhere. There are hard, wet ones that are constantly
changing as the tide rolls their components—sand, spume, shells, and snails—
into new positions. There are soft mosaics, fine as China silk when Oriental poppies
open their pink-orange parasols in the sun. Now we are going to create in fabric
a composition inspired by these patchwork patterns that surround us.

1. The first thing needed is a collection of color chips like the ones brought home

Maple bark covered with moss and snow crystals ex-
pressed in chaining and couching by Laurie H. Gust.

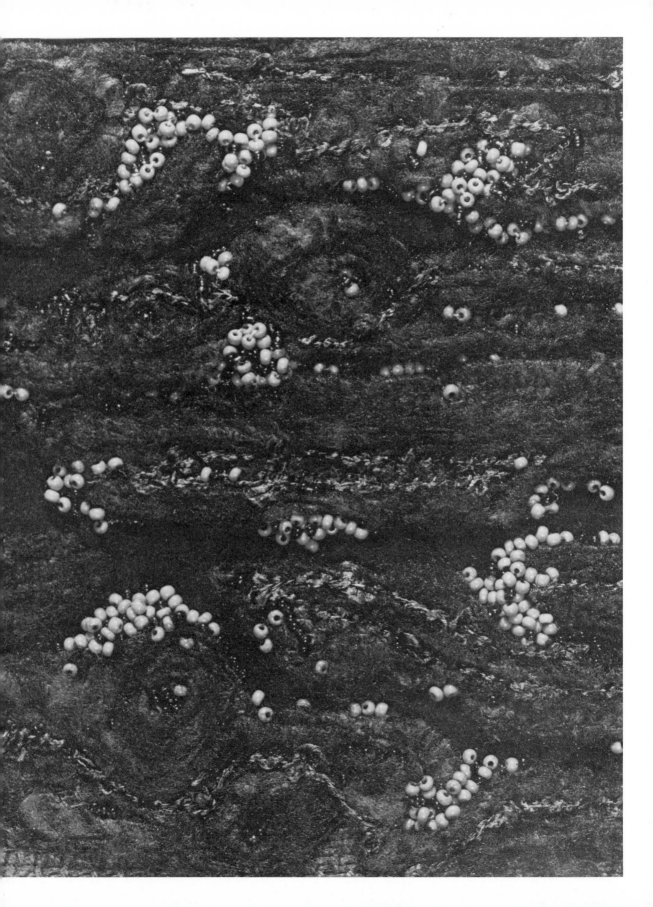

from a paint store when you are not quite certain what the blend of paint pigments should be. If the inspiration for this exercise is a mound of the sky-colored chicory that stars the roadside in midsummer, look very carefully and discover the wide range of colors to be found. There will be pale, rosy flowers about to fall off, blue-violet ones not quite open, and violet-blue blooms open-faced and in their prime. Go to a paint store and collect as many chips as you can in this particular blue range. Look also in the gray section for grayed blue-violet, eye-shadow colors. look in the brown section for cool purple-tone browns like the pool of shadow under the iris-blue petals. Look in the rose section for the magenta-touched blues. Another and more creative way to make this color collection is to take watercolor or tempera paints and drawing paper and paint 2″ × 2″ or 2″ × 3″ sections of many hue variations. Start with the base color and add the same hue, or white, black, or neighboring hues, a drop at a time. You will have dozens of squares all related by the original base color. When they are dry, cut the paper up into pieces. Make a deck of color squares or a deck of paint-store chips.

2. Buy three sheets of 9″ × 12″ construction paper and spread them out side by side—one gray, one black, one white. Spread the paint chips out on the three backgrounds and decide which value makes the best showcase for your collage. Every hue has its own place in the value scale, and it is possible, also, to find light, medium, and dark values in each one. If you decide that the black paper is the best choice, go looking for a deep, dark tone in the color you want. If it is brown, for instance, find a deep dark tone of brown wool or cotton or rayon. If the chips placed on the white piece of paper look best, search out a light beige or sand color—a high-value brown on the scale. If the arrangement on the gray paper is the favorite, look for a brown that has been softened by the addition of gray— the browns that manufacturers may call cocoa or taupe or driftwood.

3. Stretch the selected fabric and begin to play around with different arrangements of the color chips. Try some overlapping; try two layers with a hole cut out of the top one. Try putting pennies under a few of the chips to elevate them slightly. No natural mosaic looks as though it had been flattened by a lawn roller. There are many different levels.

4. Explore any fabric sources you can find. Swatch books discarded by an interior designer or a furniture manufacturer are excellent. Collect any and all in the blue range in whatever material they happen to be. Look for tones in cloth to match the paper ones. Look for coarse weaves and fine ones, pile weaves such as velvet and corduroy, stain weaves such as ribbon, polished cotton and sateen. Keep moving and turning and manipulating the pieces until you have a grouping you like. Remember that full-intensity colors tend to advance or remain in the foreground, while the cool, thinner ones fade back into shadows. Think about the raw unfinished edges. Some of these can be buried under other swatches; some can be turned under and tacked, and some could be fringed to make a soft blending over the adjacent sample.

5. When the composition is ready to be permanently attached to the backing, consider a variety of stitches, depending on the fabrics involved. Blanket stitches

will work for some, a border of French knots for others. Nik Krevitsky of Tucson, Arizona, works on large fabric collages spread out on a table and then simply uses a tacking or stabbing stitch to hold the textiles in position. The stitches are compatible with the size of the project and compatible also with the stiff, often harsh growth lines of the desert that furnish some of the inspiration for Krevitsky's work.

6. Before going ahead too far in sewing the pieces of your fabric mosaic together, consider the possibility of raising some of the shapes to give dimensional interest. This is what you did when you put pennies under some of the paper chips. The mosaic becomes more interesting because shadows and highlights are formed.

There are three simple ways to elevate or round some parts of a textile mosaic. The first and easiest is padding and quilting. Turn under the raw edges of one of the fabric shapes and blind-tack it to the background. Leave an inch-size opening through which you can poke small tufts of polyester fiber fill. This can be packed loosely or tightly, depending on how much roundness is desired. Now the opening is closed and tacked. Small quilting stitches can be used to punch down some of the padded area and break it up into smaller units.

The second method is to manipulate some of the fabric puzzle pieces into folds or pleats or gathers before they are attached. Gathering or shirring are self-explanatory, but smocking needs a little more explanation. On the wrong side of the cloth mark a row of dots at half-inch intervals. In the second row move the dots over half an inch and mark the third row as you did the first one. Using a needle and thread, pick up the pencil dots on the wrong side with a small running stitch. Do each row with a separate length of thread, leaving a loose end at both the beginning and the ending of each row. Pulling these thread ends will condense the fabric into small pleats. Tightening up the second row and then the third will make diamond shapes form in the cloth.

There is a form of stuffed quilting called trapunto—usually attributed to Italian textile designers. This third method consists of raising small islands or motifs in high relief, using machine stitching and a double layer of cloth. The planned design is drawn on the cloth with chalk and backed with a thinner piece of cloth slightly larger than the design. The outline of the motif is then stitched around by machine. Turn the piece over, make a short slit in the thin bottom layer. Through this small opening force small amounts of filling until the motif is delineated as a form rising from the flat plane of the cloth. A knitting needle can be used to tuck the stuffing into every corner, and the slits can be sewn together with a few short hand stitches.

Any of these raised techniques are best done when the background is stretched flat and wrinkle-free, either clamped in a hoop or attached to a frame.

Many of the fabrics available for your mosaic have the tactile interest of materials taken straight from nature. There is brushed denim like the gray-green of milkweed pods, Qiana fabric like the silk inside the pod, the rusty suede of cattail rushes, and the cobbled quilts of Appalachia, gleaming like puffballs after a rain.

111

THE ORIGINAL CATHEDRAL'S GLASS

The great light of ten thousand footcandles of summer sun washes over us like a shallow tide on a sandbar, and we feel warmed internally and languid with euphoria, and "The great sun overflows; the year burns on," as it did for Henry Beston in *The Outermost House*. Children respond to this warm light with a sudden flurry of activity, such as rolling rapidly downhill like a log, or pole vaulting exultingly over water-filled ditches. On the prairie Hamlin Garland saw its full magnificence:

> *The sun up-sprang,*
> *Its light swept the plain like a sea*
> *Of golden water, and the blue-gray dome*
> *That soared above the settler's shack*
> *Was lighted into magical splendor.*[1]

A toddler discovers that one index finger outstretched can block from view a bedroom light, his mother's face, or the whole sun, if he wishes. A very early game of peekaboo shows him how to spread his small fingers over his eyes and allow the lamplight or some familiar face to show through the spaces. His short fingers become opaque verticals backed with light.

Man has long venerated trees—those strong dark verticals whose living presence gives us an actual, viable connection with generations past and those still emerging. In West Africa the silk-cotton tree may attain a height of three hundred feet, dwarfing man and his toy-like creations. The blade-shaped roots form room-like buttressing to support its great height. In California, as one's head rolls back in contemplation of the enormous upward sweep of the great sequoias, it is easy to understand why trees were revered and worshiped, why the Nootkas of Vancouver Island asked permission of the tree before stripping the cedar of its bark for weaving or before cutting the whole tree for a long canoe or a totem. Solitary trees and groves of them (especially in West Africa) became sacred objects and places of contemplation. Against the sky their strength was awesome, and the touching branches of adjacent trees interlocked to form great ellipses in the air.

These living Gothic arches were imitated in man's first cathedrals with their vaulted ceilings soaring heavenward. There was a great interest then in bright-colored objects that reflected light as burnished gold, rubbed silver, and faceted stones. A small niche-like opening, a fenestella, was often cut into the south

113

In the heart of a vintage sycamore, branches frame triangular pieces of sky. Photograph by Dick Wesley.

wall near the altar so that the church's brilliant treasure could be seen through it by those passing by.

The first window was probably made of oiled fish skin or a thin piece of vellum. In the simple cabins made of notched lodgepole pine in the American West, the thin skin of a doe was stretched tightly in the window frame so the light could enter. In Eskimo igloos a square of ice replaced one of the snow building blocks, and a slab of snow set at right angles to it reflected the sun's low light into the enclosed living space. In the twelfth-century cathedral windows there were often thin sheets of marble or alabaster that allowed a soft translucent light to filter through.

In the warm sun of Indian summer you can picnic in a cathedral-like stand of golden sassafras, and the warm light may be so intense that you feel dyed with a molten liquid gold—as though you were quiet in an ancient cathedral in which all the windows were leaded with amber glass. The "Gloria" window in St. Peter's in Rome is a small oval made of all yellow-gold glass. It is said that when brilliant sunshine floods through it, the light overflows and covers everything it touches with a warm aurora.

Just so the shimmering beauty of constantly moving aspen stands in Colorado are described by Ann Zwinger in *Beyond the Aspen Grove* as a "blazing light, a torch holding back the winter frosts." The sound of their flat leaves constantly turning she describes as "intermittent rustlings of gold tissue-paper wrapping up the glow of summer."

When the first wall openings were filled with glass that had been colored with mineral oxides and then rolled but not polished so that the surface remained rippled or uneven, artists found that they could change and control the quality of the light inside. Such a window provided its own light source and appeared most luminous when there was no interior light. The mullions of lead and the stone columns between the arched openings became, like the trees, black opaque verticals against the sky and heightened the effect of the splendid luminescence. The decorative detail called tracery lights at the top of the Gothic arched windows were like the fine twig patterns at the ends of branches.

Colors were brilliant, saturated hues that ranged from marine green, cobalt blue and purple to ruby and topaz—the glory of a suddenly seen hummingbird filling a whole wall. Marston Bates, in *Land and Wildlife of South America*, describes the effect:

> The colored portions of the feathers, most often those of head, neck and chest but also frequently of flight feathers in wings and tail, are covered with a film of tiny elliptical platelets so infinitely small that only the electron microscope can show them. It is this reflective film which produces the astonishingly pure spectral colors seen in the changing light as a hummingbird flicks past.

Seen through a tangle of raspberry canes or a winter asparagus bed, looking like spun sugar that has caramelized, the setting sun is splintered (like the humming-

114

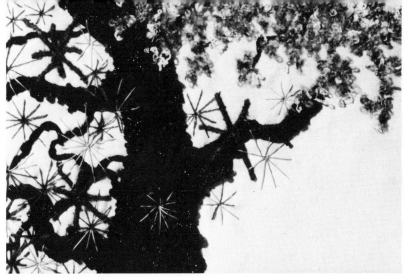

Winter Oak. Trapunto with couching, hooking, and beads by Marjorie Graeff.

bird's throat) into a hundred shards of color resembling the mosaic-like medallion windows that were made of many small glass pieces held together with fine leading.

In winter one sees the bare tree branches in wrought-iron silhouette against the sky. The diminished sunlight, when it does appear, often does so unexpectedly, between drifting cloud forms. A sudden spotlight focuses on a pin oak with brown paper leaves rustling in the wind, or backlights the elm fountains forming a vaulted archway over a farm lane. Every day at the year's end you can see the sunrise turn familiar shrubs into flat designs scissored out of black paper backed with glowing rose or gold or tangerine as the flattened disk of the sun slowly lifts above the horizon. Sunset comes before the working day ends, and homeward-hurrying motorists have time to glimpse the glory in the western sky as heavy snow-filled clouds part briefly and a shaft of cold light backlights every stark and bony weed along the roadside. Anne Morrow Lindbergh describes the experience:

> Going home at sunset. The sea becomes sky at this time—so smooth—and colors like a pigeon's throat (the ring of feathers around their necks—iridescent pink, green, blue, pearl).[2]

Some days in winter there is not enough direct light to form shadows, and the whole landscape is a value study in a low key—chiaroscuro style. The etching of branches and the script lines of vines that link shrubs are antique ink against a lighter gray paper—a flat-painted monochrome like the grisaille modeling of cathedral windows in which the painted-on details of oak and ivy and hawthorn leaves lent a silvery appearance to the glass.

On such days the only clue to the actual presence of the sun is a subtle area of lighter gray that slowly drops in the west. On either side a spot of lesser light, a false sun, or sundog, may appear briefly. The tree verticals are ebony against a pewter-to-white-smoke sky. The air sparkles with snow crystals, and the sunset light is a cold grayed yellow, greened at the top and pinked at the bottom.

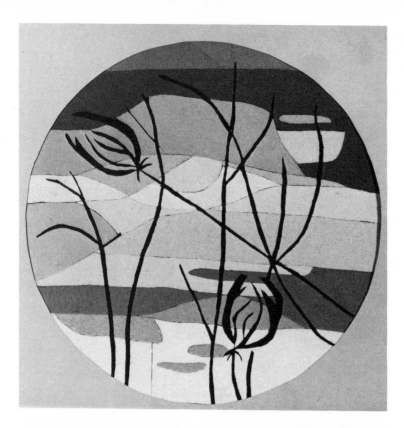

The dry ovals of Queen Anne's lace in silhouette inspired this appliqué by Helen K. Villard.

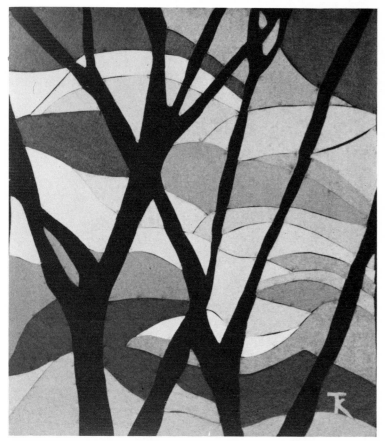

The end of a winter day. Felt on corduroy by Tamie Kaweck.

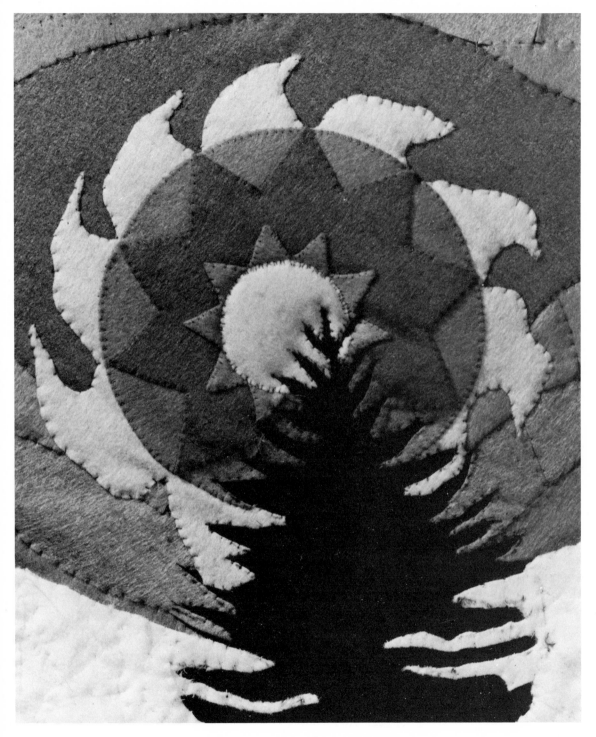

The drama of a winter sky. Felt appliqué and subtraction by Robin Curiak.

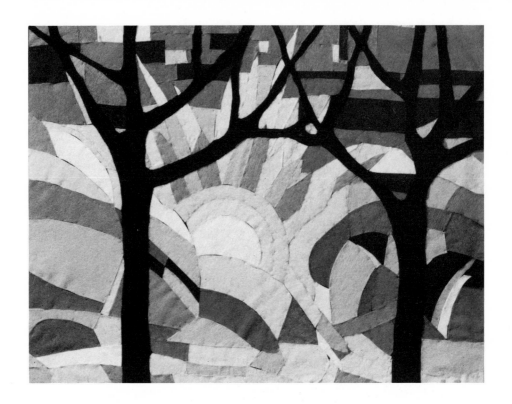

Finding Church Windows
Without Any Church
Compositions in Reverse Appliqué

1. Study the sky in late autumn or winter or early spring. Do this at intervals during the day. Using a small frame cut out of a filing card, look at both the setting and the rising sun. Now look at the afterglow reflected in the sky behind you. Try to see differences on successive days. Become conscious of sky light. On a tracing pad draw squares or rectangles in the same proportion as the cutout viewer, but make them fill the page. Do five or six, only one per page, and color the paper in the same hues you saw in the dawn or evening sky. Any crayons, felt pens, or chalks will do, but watercolors are not recommended because they will blister the paper. Study each page and decide which of your sky sketches you would like to develop further.

2. Cut several viewers, perhaps square, rectangular, or round, but do not make the cutouts any more complex than these three geometric shapes. A triangle, with its three sharp points demanding attention, is too interesting for our purposes here. Now, with viewers, pencil, and sketchbook in hand, venture outdoors, with gloves if you need them, and find some interesting compositions of tree

branches or those of shrubs and winter grasses. Pretend you are taking a close-up shot with your camera, so that it is not possible to capture a whole tree or a complete viburnum. Instead you will see lines that stand straight or curve out and cross each other. Some of the branch and twig lines will go completely out of the picture. Record what you find in pencil on the pages of the sketch pad, within the frame you drew before leaving home. Try half a dozen or so. Look both high and low, down to knee or ankle level. Try to find very different natural lines, like the smooth arching wands of willow or the rough-angled ones of oak. As you look at these lines against the sky, you will find that often a branch curving up or out and across another has cut up the sky behind it into pieces of color framed by the bare branches—just as do the lead strips that hold together the pieces of colored glass in the window of a cathedral or country church. These window leads are called cames, and the branch lines you have been sketching are natural cames.

3. When you get back indoors, go over the timid pencil sketch lines with a wide black felt marker. The heavier branches could be indicated with several broad strokes of the felt pen. Study all the pages and decide which one you want to develop further.

4. Make a rough wooden frame or put together a stretcher frame. If you plan to work in a circle, buy an embroidery hoop about fifteen inches in diameter. Find a piece of black or dark-colored cloth to stretch over the frame. It could be charcoal or navy, walnut, deep purple, a low value of green, or almost any dark tone except maroon. The fabric used should be fairly smooth, but a twill or cord weave might add textural interest. Now, stretch it tightly over the frame, using a staple gun or thumbtacks set half an inch apart. Be sure to pull out all the wrinkles. The fabric should be as tight as a drumhead.

5. Take the sky stretch you plan to use and find the same or similar colors in felt. You will have to do some simplifying because felt comes in a smaller range of colors than those you created by blending colored inks or crayons. Felt is available by the yard, but it is more economical to buy it in the 9″ × 12″ squares sold by craft and dry-goods stores.

6. Now cut the felt into strips or slices that fit tightly together, like the pieces of a puzzle, and try to reproduce the sky sketch by covering the tightly stretched dark cloth with the felt pieces. When you determine where a piece should go, you may wish to tack it in place temporarily with a stitch or a pin. The cloth should be completely covered with no dark lines showing.

7. The next step is to decide which composition of twigs and branches will be used. Superimpose this on the felt background by sketching the lines lightly with chalk. Then, with sharp scissors, carefully cut away a narrow strip of felt, exposing the dark background to serve as the winter branches. Two pieces of felt can be separated very slightly to produce a fine twig-type line.

8. Now the felt pieces need to be permanently stitched in place. Use thread to match the felt and with tiny running or stabbing stitches invisibly tack the color to the cloth. The stark dark lines where you cut away the felt will make a stained-glass window out of the felt sky—a good example of design by subtraction—reverse appliqué.

119

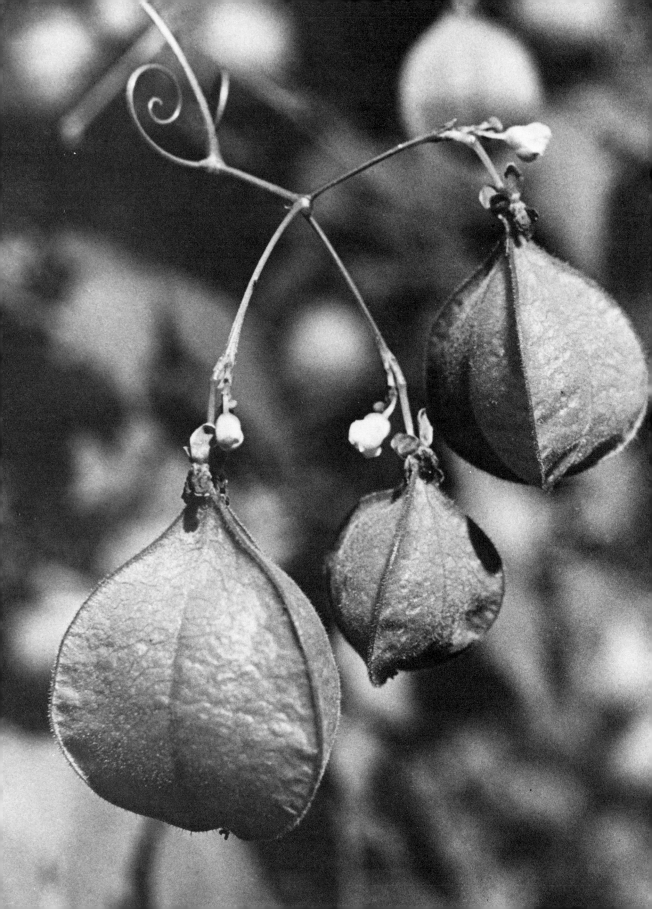

ABOUT DESIGNING

Nature is the great inexhaustible well into which each individual designer lets down his little cup and dips.[1]

Designing begins with seeing. The artist who creates with a needle or a shuttle or a hook needs to be aware of every detail of the environment—to observe closely every aspect of the natural habitat just as the traditional artist does who may work with a brush, a scriber, or a chisel. No two hikes are ever the same. There are always leaves that have fallen, buds that have opened, bark that has curled—some small detail added or subtracted since the last viewing. The same cedar log seen on different days, at different hours, in different forms of light reveals completely different potentials for design. In Leonardo da Vinci's familiar words:

> The eye, which is called the window of the soul, is the chief means whereby the understanding may most fully and abundantly appreciate the infinite works of nature . . . All visible things derive their existence from nature, and from these same things is born painting.

Close and continued observation of nature provides a list without end of textures, forms, and patterns to be interpreted in yarn or thread. Rachel Carson once wrote an article for the *Woman's Home Companion* titled "Teach your Child to Wonder." This grew into a slim volume with hauntingly beautiful photographs of a small boy exploring the wonder of the Maine coast. The book, completed after her death, was titled *The Sense of Wonder.* Her main object in the book was to interest parents in developing an aesthetic awareness in children. She did not feel that you had to learn the scientific names of each weed or bird or flower to do this. It was her idea rather to kindle a curiosity in the child that would remain throughout life: "It is more important to pave the way for the child to want to know than to put him on a diet of facts he is not ready to assimilate."

Close observation means a sensitive seeing. One needs to see the details to appreciate the whole. Elizabeth Burroughs Kelley, granddaughter of the naturalist, John Burroughs, noted that single flowers just open and bloom, but some composites like the teasel start blooming in the middle and the opening flowers spread up and down from the center. In the case of the pale yellows of mullein and evening primrose, the bloom creeps upward to the tip, whereas the pasture goldenrod spreads its bloom downward from twig to twig. These are small details that

121

The seed pods that cradle new plant life are often the temporary apartments of insects. Photograph by Dick Wesley.

escape the notice of the casual observer, but they are of great interest to a craftsman looking for ideas for design. In *With John Burroughs in Field and Wood* Mrs. Kelley includes her grandfather's observation: "Power of attention and a mind sensitive to outward objects, in these lies the secret of seeing things."

Designing is trying. Designing is trying and rejecting and trying and rejecting and trying. Starting first with a wisp of an idea floating in space or one that has been quickly sketched, the designer begins by turning the image over and over in his mind until one solution or one idea seems possible or worth detailing further. There may be a long period when the idea hovers just below the level of consciousness before active designing takes place. In his notes Theodore Roethke wrote: "The nobility of the imagination is my theme: I have to let things shimmer."[2]

Designing is interpreting. As in a painting class where no two students see the model in exactly the same way, so no two craftsmen will see the same possibilities for design, given the inspiration of the same natural phenomenon. The fluted slenderness of a goatsbeard pod about to open might suggest to one designer the crisp architectural quality of a macramé column. To some other textile designer this same ridged ovoid might suggest the concentric coils of basketry or the firmness of the tent stitch in canvas embroidery. To be inspired by nature but not to copy what is discovered should be the craftsman's goal. As Harriet E. Baker once wrote, ". . . the artist must not delude himself that a faithful 'copy' of nature has any more value than a counterfeit coin. Aside from curiosity value a copy of anything is essentially worthless."[3]

A designer should carry a sketchbook and record briefly what is seen. Sunlight coming in a golden shaft of light through a leafy branch might appear on a page as a series of simple leaf outlines side by side, overlapping or changing position so they appear to lie at different levels just as they did in the woods. This small experience could be used by the textile designer in many ways, and thus the experimental and developmental stage of designing begins. Dye is transparent color, and the lapped leaves and their show-through hues could be interpreted with liquid color, as in batik, or with denser color, as in a print where the position of the block or the screen or the stencil was slightly altered for each impression, making translucent overlays of green and gold. In another mood the sunlit branch might suggest an appliqué done with overlapped cutouts of organdy and tulle. Still another approach might be a patterning in thread to give the same effect of layering by superimposing one leaf image over another, using threads as contour lines to describe the outline of each leaf. The fragile, fleeting quality of the experience might be caught by using the tools of a lacemaker. Working within the confines of an empty hoop and creating the effect of layered growth by crossing and looping and interlacing the bobbins, a craftsman could fabricate a delicate, dreamlike sequence in gauze. If the craftsman is also a weaver, the suntouched leaves might become an inlay with shaggy linen threads used as a discontinuous weft, supplementary to the tabby weft, as the designer weaves a simple statement of leaves in sunlight on the loom. In any method of working

it should be a natural experience distilled, as Wordsworth suggested in "Upon the Sight of a Beautiful Picture," "To one brief moment caught from fleeting time."

The object of designing, the hoped-for result, is the capturing of the essence or the mood of the experience, not the exact detail. The composition should look like an appliqué, a stitchery, a block print, or whatever the medium was that the designer used. It should not resemble an etching or a photograph or a blueprint, all of which are botanically and mathematically correct. The aim should be to capture the impression, not to record the image precisely as the camera does. One writer has described a snapshot as a bit of nature embalmed in photographic emulsion.

Other designers, too, who work with sentences and rhyming lines, are interested in threads and textiles. For some years I have been intrigued by the constant discovery of textile terms, in all fields of writing, by authors trying to describe and delineate an idea. Here, from John Alec Baker's *The Hill of Summer*, is a bright, exciting picture of a redstart in a larch tree:

> There is a sudden fire-light of wings. A redstart perches in a larch, shining through a moving lace of shadows. Below the pale grey crown, the redstart's forehead is a slash of pipe-clay white gleaming like paint laid on thickly with a palette-knife; the cheeks and throat are a deep cindery black, the chest a segment of rich orange, the belly a clear white like the white of an egg; the back is grey, the tail a copper gleam.

The color excites, and the bold clear tones of the bird are emphasized by the contrast of "a moving lace of shadows." The image is strong and brightly gay. In Sidney Lanier's poem "A Florida Ghost" lace is a verb that heightens an effect of delicate tracery as he describes the Florida Keys "That laced the land like fragile patterns wrought/To edge old broideries." In "The Rose" Theodore Roethke evoked another textile image, writing of patterns formed in water as "the lacelike wrinkles of the wake."

The success of a textile design project, like that of any original creation, may lie in the honest use of materials. A smooth, light-reflecting synthetic yarn should be used for what it is—a shiny, sophisticated line not at home on hand-spun linen. Vinyl should not masquerade as leather just because it is cheaper, easier to procure, and easier to cut. William Morris is known as a designer of furniture, but he was also a craftsman who mixed dyes for draperies and printed custom wallpapers with blocks carved out of pear wood. In his writings, he gave this advice to craftsmen:

> . . . try to get the most out of your material, but always in such a way as honours it most. Not only should it be obvious what your material is, but something should be done with it which is specially natural to it, something that could not be done with any other.

Every textile material has intrinsic qualities useful in some special way. Used honestly, each can contribute to a successful textile design. Corot once said, "Truth

is the first thing in art and the second and the third." Like "honesty," another old-fashioned word for textile designers to tack up on a bulletin board is "simplicity." This means simplicity of subject, of line, and of texture. The designer should be wary of overstatement. Rather the aim should be to understate the theme as an impressionist painter or a contemporary poet does when he suggests by innuendo and partially phrased thought what he wants the viewer or reader to see or to feel. William Morris, who simplified viable natural forms into fluid motifs that were flower-like rather than imitative of any specific flower, honed and whittled down his designs to the simple beauty of the understated form—like that of driftwood after the tide, the sea, the sun, and the salt have removed all extraneous parts and polished it smooth. His interest in the elegance of simplicity in art led him to write in *Hopes and Fears for Art*: "Be very shy of double flowers; choose the old columbine where the clustering doves are unmistakable and distinct, not the double one, where they run into mere tatters."

The textile designer should eliminate any color or texture or line or value that isn't needed to produce the desired impression. William Morris again: "Simplicity of life, even the barest, is not a misery, but the very foundation of refinement: a sanded floor and whitewashed walls, and the green trees, and flowery meads, and living waters outside. . . ." Morris would have enjoyed the noble simplicity of Georgia O'Keeffe's New Mexico and of her single blossoms enlarged to fill a whole canvas.

Designing then begins with seeing and feeling and moves into an experimental stage where many things are tried and discarded but few are saved. As the idea develops, it is turned over and over like a wave-tossed petoskey stone until the essence only remains—one that is right and compatible and pleasing. Close scrutiny of nature has filled the designer's sketchbook with a myriad of ideas far removed from the current owl and mushroom syndrome. The textile designs developed from these shorthand notes will be refreshingly original—one-of-a-kind pictures in thread. As suggested by the example of the sun-touched leaves discussed earlier, the craftsman tries to distill the essence of the experience rather than copy details exactly or repeat verbatim someone else's idea. He gives it a new slant, capturing it as Theodore Roethke does in "I'm Here," from *Collected Poems*:

> Look at the far trees at the end of the garden.
> The flat branch of that hemlock holds the last of the sun,
> Rocking it, like a sun-struck pond,
> In a light wind.

Richard Jefferies reinforces the idea that nature teems with ideas for the designer working with fibers and fabric. In *Field and Hedgerow* he observes, "You do not know what you may find each day; perhaps you may only pick up a fallen feather, but it is beautiful, every filament. Always beautiful! Everything beautiful!" In *The Open Air*, using the same motif, he describes a swallow's feather as "fuller of miracle than the Pentateuch."

About designing, then—awareness is the first step, and exploration and sim-

plification are the second and the third. Nature is always there as an inexhaustible source of ideas. In many places today man has unrolled asphalt ribbons where no bird can nest. He has sprayed roadside ditches with defoliants, leaving bare brown skeletons of brush that bone-dance in the wind. But in the concrete world of the inner city it is still possible to fill a paper cup with soil, dampen it, and watch the growth design begin. A designer looks at the seedlings with a conscious seeing. The smallest details are noticed, as they are when the seasons change. In early spring beech leaves are tissue-paper cornucopias sibilant in the wind. They become pale wet transparencies icebound in the last of April's snow as they are pushed off the bough by burgeoning buds like pencils newly sharpened. The slow-motion pace of winter's black and white becomes in May a movie strip in Kodachrome with the speed stepped up. Stark beauty becomes softened line. The designer feels the wool on the sheep's back, feels the lanolin smooth his skin as the pulled yarn runs through the fingers from the distaff to the bobbin—feels the textures of moss and of cattail fluff, looking, in early spring, like tissue left out in the rain. Each natural experience is distilled, edited, polished until only the captured essence remains. Beauty, said Leonardo, is "arrested grace."

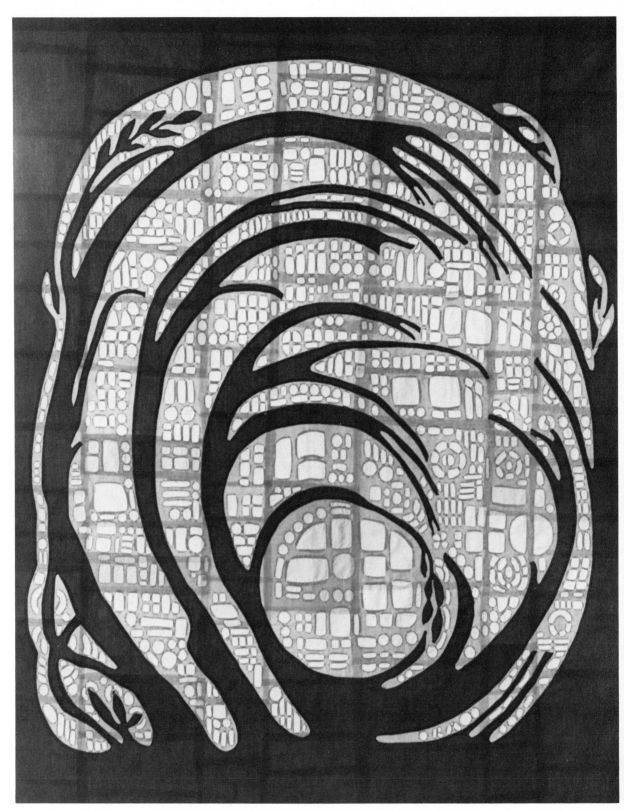

Gloria, a wind-warped tree against an evening sky. A layer of patchwork was covered with gray and then purple cotton to make the three-layer textile for this reverse appliqué by Grace O. Martin.

EPILOGUE

But as upon that sun-warmed rock I lay
Joy stirred within me with a lift of wings.

—Dorothy Peace, "A Sea Change"

In the preceding folios an attempt has been made to awaken in the reader these twin concepts: that every individual's micro-environment teems with great beauty, limitless inspiration for design, and that every individual's enjoyment of life can be measurably increased with a sharper acuity.

Loren Eiseley's books are found in the knapsacks of today's students who can relate to the philosophy he expressed in *The Immense Journey.*

> We have joined the caravan, you might say, at a certain point; we will travel as far as we can, but we cannot in one lifetime see all that we would like to see or learn all that we hunger to know.

When one begins to seek out the books and journals of authors who have shown an awareness of the earth's fragile ecology and a keen sensitivity to the heartwarming beauty that surrounds us, one finds that there was and is a great bond between those writers even though they lived in different places and in different times. Rachel Carson kept a copy of Henry Beston's *The Outermost House* on her bedside table (along with a volume of Richard Jefferies) to turn to when sleep would not come. One can imagine the amber circle of lamplight in the dark as the surf broke at the edge of her constant sea. Beston's words ring like a Benedictus:

> Touch the earth, love the earth, honour the earth, her plains, her valleys, her hills, and her seas; rest your spirit in her solitary places.

And again, in *Herbs and the Earth:* "It is only when we are aware of the earth and the earth as poetry that we truly live."

And she who once observed a firefly trying to communicate with a phosphorence in the night sea might underline Beston's sentences in *The Outermost House* about the beauty of the dark: "With lights and ever more lights, we drive the holiness and beauty of night back to the forests and the sea."

When the energy crisis turned the nation's clocks back and letters to the editor blazed with references to the dark ages and the furtive night, a thin volume of poetry that was too late for Carson's bedside—a small one with the improbable title *Farming: A Handbook*—carried Wendell Berry's plea for an awareness of the beauty of the night. As in his poem "To Know the Dark":

> *To go in the dark with a light is to know the light.*
> *To know the dark, go dark. Go without sight,*
> *and find that the dark, too, blooms and sings,*
> *and is traveled by dark feet and dark wings.*

The other book on Rachel Carson's table under the lamp was the work of Richard Jefferies, who in his brief life wrote twenty-three books and journals without being repetitive. In *The Story of My Heart* he says:

> For I thirst with all the thirst of the salt sea and the sun-heated sands dry
> for the tide, with all the sea I thirst for beauty. And I know full well that
> one lifetime, however long, cannot fill my heart.

Beston felt that without the earth man was "but a vagrant in space." In *Herbs and the Earth* he explains that only a viable connection with the earth would allow man to be "as one with all who have been and all who are yet to be, sharers and partakers of the mystery of living, reaching to the full of human peace and the full of human joy."

That word "joy," golden with the sound of trumpets, appears again and again in writings old and new that attempt to describe the natural scene. In this Eskimo song the feeling is felt and shared in a few words grouped in a few lines.

> *There is joy*
> *In feeling the warmth*
> *Come to the great world*
> *And seeing the sun*
> *Follow its old footprints*
> *In the summer night.*[1]

And another Eskimo balladeer who could feel the flow and ebb of the sea known to Rachel Carson and who could hear the gulls wheeling and crying in the windy skies as they did for Henry Beston has left us this legacy:

> *The Great Sea has set me in motion*
> *Set me adrift*
> *And I move as a weed in the river*
> *The arch of sky*
> *And mightiness of storms*
> *Encompasses me*
> *And I am left*
> *Trembling with joy.*[2]

128

This word "joy" is a small one but heavy with feeling. In one of the carols it is repeated three times in gradual crescendo, and when sung with a full choir it has the power to lift the spirit almost bodily. Elizabeth Burroughs Kelley tells us that her grandfather, John Burroughs, called life's three great resources friends, books, and nature. He described nature as "an inexhaustible storehouse of that which moves the heart, appeals to the mind, and fires the imagination—health to the body, a stimulus to the intellect, and joy to the soul."

Young people today are turning to the crafts as never before. They are firing raku pots, dipping beeswax candles, casting pewter, tying clove hitches, and spinning wool with a fervor this country hasn't seen since frontier days. They are becoming acutely aware of the environment and translating this keener observation of natural forms and textures into original expressions in the hand arts. The joy that follows the creative process is the pure pleasure that results from the forming of a completely unique object and one that found its genesis in close observation of nature. The joy of creative expression knows no generation gap. Retirees who have a high degree of awareness live a life that overflows with meaning. They are constantly involved with projects and never seem to have enough time for any one of them. They are exciting people to know because some of the joy of creativity emanates from them. They have learned or re-learned the thrill of discovering beauty in sudden and unexpected places.

Every child is born with a high degree of awareness, but in adults this quality that adds so much to the full enjoyment of life has often atrophied from disuse. An infant in a crib is acutely aware of a dapple of sun on his quilt. He explores the edge of the shape, tries to pick it up, feels its warmth. An older child might shift the cover or his body underneath the quilt to watch the colors change in sun and in shadow, but an adult may miss completely this momentary oval of gold.

Man's capacity for awareness Marston Bates described as one unique in nature because it involves not only perception, a curious alertness, but also the ability to think and analyze, to keep verbal and written records, and to share ideas. This awareness quality can be learned. Awareness can be acquired.

If you try to analyze just what this awareness quality is, you find that to be aware is to be taking note of what is seen. Taking note becomes taking notice—a conscious seeing. Just as a camera records an instant in time and reveals in the resulting photograph a sky more intensely blue than was remembered, or a grandfather's imprint on the face of a child—just so an artist captures and holds his impression of a passing moment, whether he works in charcoal or dye or homespun wool.

"We are made so that we love, first, when we see them painted, things we have passed perhaps a thousand times, nor cared to see." So said William Morris in *Hope and Fears for Art*. He was an artist with a passion for pattern. His motifs were sketched directly from nature, then simplified and repeated in rhythmic progression as patterned borders on fabrics, walls, leather. He was intrigued with the lyricism of orderly repeats of leaves and stems and flowers linked together in close proximity—such as teaspoons lined up in neat rows on a table or milk-

weed parachutes lined up, scalelike, in furry pods waiting to become airborne. It was nature, seen, felt, and recorded, that filled his storehouse of patterned images, just as it inspired Sir Joshua Reynolds:

> It is in nature only that we can find that beauty which is the great object of our search; it can be found no where else: we can no more form any idea of beauty superior to Nature than we can form an idea of a sixth sense, or any other excellence out of the limits of the human mind.

As our cities fringe out over the open fields and ravel up the tree-crowned ridges, the natural world becomes less accessible to the very young, the very old, and the people in between who hurry by with their blinders on. We are becoming cognizant of the rights of each member of society. Every group has a champion, and the conservationists, the naturalists, and the ecologists are gaining converts every day. The ecologist defends the right of every earthling to experience natural beauty. Aldo Leopold in *A Sand County Almanac* champions the rights of each citizen:

> . . . the opportunity to see geese is more important than television, and the chance to find a pasque-flower [the fur-coated prairie crocus that blooms only in virgin soil that has never felt a plow] is a right as inalienable as free speech.

Wilderness areas are being set aside, but the wilderness at our doorstep—the jungled green of a roadside ditch, the grass-whiskered strip along a fence row accessible to all to see—is being drained, filled with chunks of broken pavement, and sprayed with defoliants that leave it naked and dead. City children grow up without touching the ground.

Although the natural environment is shrinking daily, awareness has little to do with the place one lives, the paths one travels. A high-rise apartment far from the ground and the earth on which it rests is closer to the stars. The sky, constantly changing from hour to hour, week to week, is a film strip showing sudden or subtle differences in light, line, and texture in every frame. Unlike a movie sequence, a film strip is easy to stop in order to study a frame again and again to etch it on the memory slate. Our paths have a sameness about them just like a repeated film strip. Traveling the same stretch of highway or the same row of buildings day after day makes motion easy and frees the mind for seeing details not noticed on a previous trip. Remember a tree that you pass every day. Do the branches droop or lift up at the tips? What shape are the leaves? What sound do they make? How do they fall?—if they fall. What yarns would you choose to give the feeling of the bark? What fabric would you choose for the sky—a soft gray flannel for a January dusk or a thin muslin—the pale citral of April? Feel the idea with the fingertips of your mind. Toss it around when traffic stalls, as the elevator rises, as the school bus lumbers over a hill. Think about it when sleep won't come or while you wait your turn. Think about it. Then take creative action, and the joy will follow.

Notes

Additional publication data may be found in the Selected Bibliography.

Introduction
1 Henry Beatle Hough, *Singing in the Morning and Other Essays About Martha's Vineyard.*
2 Laura Watson Benedict, as quoted by Gertrude Whiting in *Tools and Toys of Stitchery.* New York: Columbia University Press, 1928.

Folio 1 NATURAL LIGHT
1 Robert Bly, "A Late Spring Day in My Life," *Silence in the Snowy Fields.* Middletown, Connecticut: Wesleyan University Press, 1962.
2 George Opdyke, *Art and Nature Appreciation.* New York: Macmillan, 1932.

Folio 2 THE ORIGINAL OUT-DOOR CARPET
1 Bly, "Approaching Winter," *op. cit.*
2 Bliss Carman, "A Vagabond Song," *Songs from Vagabondia,* William Bliss Carman and Richard Hovey. New York: Dodd, Mead, 1896.
3 Robert P. Tristram Coffin, "The Secret," *Collected Poems.*
4 Walter de la Mare, "The Listeners," *Collected Poems.* London: Faber and Faber, 1942.
5 Louis Untermeyer, "Wanderlust," *Blue Rhine, Black Forest.* New York: Harcourt, Brace and Co., 1930.

Folio 3 NATURAL LINE: FINITE, INFINITE, CONCENTRIC
1 Henry David Thoreau, *Cape Cod.*
2 Ann Zwinger, *Beyond the Aspen Grove.*
3 Virginia Eifert, *Journeys in Green Places.*
4 Wendell Berry, "The Man Born to Farming," *Farming: A Hand Book.*
5 Henry Williamson, *The Lone Swallows and Other Essays of the Country Green.* New York: E. P. Dutton & Co., 1926.
6 Malcolm Cowley, "Tumbling Mustard," *Blue Juniata.*

Folio 5 NATURAL DYES
1 Oliver Wendell Holmes, *The Professor at the Breakfast-Table.*
2 Rudyard Kipling, "Christmas in India," *East of Suez.*
3 Edwin Arlington Robinson, "Pasa Thalassa Thalassa."
4 Coffin, "Cider Pressing," *op. cit.*
5 Ronald Latham, *The Travels of Marco Polo.* Harmondsworth, Middlesex, England: Penguin Books, 1958.

Folio 6 NATURAL LIVING SPACES
1 Alexander Wetmore, *Song and Garden Birds of North America.* Washington, D.C.: National Geographic Society, 1964.
2 Edna St. Vincent Millay, "Journey," *Collected Poems.*
3 Thoreau, *The Journal of Henry D. Thoreau,* edited by Bradford Torrey and Francis H. Allen. Boston: Houghton Mifflin, 1949.
4 William Turner, *A New Herball, First and Seconde Partes.* London: Imprinted at Collen by Arnold Birckman, 1551? (1562).
5 William Shakespeare, *Henry V,* Act V, Scene 2.

Folio 8 THE ORIGINAL CATHEDRAL'S GLASS
1 Hamlin Garland, "A Human Habitation," *Prairie Songs.* Cambridge, Massachusetts, and Chicago: Stone and Kimball, 1893.
2 Anne Morrow Lindbergh, *Bring Me a Unicorn.* New York: Harcourt Brace Jovanovich, 1971.

Folio 9 ABOUT DESIGNING
1 G. Wooliscroft Rhead, *The Principles of Design.* London: B. T. Batsford, 1913.
2 Theodore Roethke, "I Teach out of Love," *Straw for the Fire: From the Notebooks of Theodore Roethke (1943–1963),* edited by David Wagoner. New York: Doubleday, 1972.
3 Harriet E. Baker, "The Nature of Art," editorial in *Creative Crafts,* Vol. 3, No. 4, Nov./Dec. 1962. Los Angeles, California: Oxford Press.

EPILOGUE

1 From *Seasons of the Eskimo*, by Fred Bruemmer. Greenwich, Connecticut: New York Graphic Society, 1971.

2 Eskimo song, "Aii Aii," translated by Tegoodligak. From *Canadian Eskimo Art*, edited and published by the Department of Northern Affairs and Natural Resources, Ottawa, Canada, 1954.

Selected Bibliography

On Art and Nature

Bager, Bertel. *Nature as Designer*. New York: Reinhold, 1966.

Ballinger, Louise Bowen, and Vroman, Thomas F. *Design Sources and Resources*. New York: Van Nostrand Reinhold, 1965, 1968.

Beatty, John Wesley. *The Relation of Art to Nature*. New York: W. E. Rudge, 1922.

Blossfeldt, Karl. *Art Forms in Nature*. New York: Universe Books, 1967.

D'Arbeloff, Natalie. *Designing with Natural Forms*. New York: Watson-Guptill, 1973.

Eisenstaedt, Alfred. *Witness to Nature*. New York: Viking, 1971.

Feininger, Andreas. *The Anatomy of Nature*. New York: Crown, 1956.

Guyler, Vivian Varney. *Design in Nature*. Worcester, Mass.: David, 1970.

Strache, Wolf. *Forms and Patterns in Nature*. New York: Pantheon, 1956.

On Creativity

Anderson, Harold Homer. *Creativity and Its Cultivation* (Symposia on Creativity). New York: Harper, 1959.

Focillon, Henri. *The Life of Forms in Art*. New York: George Wittenborn, 1948.

Ghiselin, Brewster. *The Creative Process, a Symposium*. Berkeley, Cal.: University of California Press, 1952.

Guggenheimer, Richard Henry. *Creative Vision for Art and Life*. New York: Harper, 1960.

Lewisohn, Ludwig. *The Creative Life*. New York: Boni and Liveright, 1924; New York: Kraus reprint, 1969.

Mearns, Hughes. *The Creative Adult*. New York: Doubleday Doran, 1940.

On Designing

Albers, Anne. *On Designing*. Middletown, Conn.: Wesleyan University Press, 1961.

Anderson, Donald M. *Elements of Design*. New York: Holt, Rinehart and Winston, 1961.

Beitler, Ethel J., and Lockhart, Bill. *Design for You*. New York: Wiley, 1969.

Bevlin, Marjorie Eliott. *Design Through Discovery*. New York: Holt, Rinehart and Winston, 1970.

Evans, Helen Marie. *Man the Designer*. New York: Macmillan, 1973.

Felsted, Carol J. *Design Fundamentals*. New York: Pitman, 1958.

Hurwitz, Elizabeth Adams. *Design, a Search for Essentials*. Scranton, Pa.: International Textbook Co., 1964.

Justema, William. *The Pleasures of Pattern*. New York: Reinhold, 1968.

On the Earth as Poetry

Berry, Wendell. *Farming: A Hand Book*. New York: Harcourt Brace Jovanovich, 1970.

Coffin, Robert P. Tristram. *Collected Poems*. New York: Macmillan, 1957.

Cowley, Malcolm. *Blue Juniata: Collected Poems*. New York: Viking, 1968.

Foerster, Norman. *Nature in American Literature*. New York: Russell and Russell, 1923.

Frost, Robert. *Complete Poems of Robert Frost*. New York: Holt, Rinehart and Winston, 1967.

Grover, Edwin Osgood. *The Nature Lover's Knapsack; An Anthology of Poems for Lovers of the Open Road*. New York: Thomas Y. Crowell, 1927.

Johnson, Edward Dudley. *Poetry of Earth*. New York: Atheneum, 1966.

Kipling, Rudyard. *East of Suez*. London: Macmillan, 1931. *Plain Tales from the Hills*. Rev. New York: Doubleday, Page, 1917.

Millay, Edna St. Vincent. *The Buck in the Snow*. New York: Harper, 1928. *Second April*. New York: Harper, 1921. *Wine from These Grapes*. New York and London: Harper and Bros., 1934. *Collected Poems*. New York: Harper & Row, 1956.

Roethke, Theodore. *The Far Field*. Garden City, New York: Doubleday, 1964. *Open House*. New York: A. A. Knopf, 1941. *Words for the Wind*. London: Secker and Warburg, 1957. *The Collected Poems of Theodore Roethke*. Garden City, New York: Doubleday, 1966.

Wagoner, David, ed., *Straw for the Fire: From the Notebooks of Theodore Roethke 1943–1963*. Garden City, New York: Doubleday, 1972.

Wordsworth, William. *Poetical Works*. London, New York: Oxford University Press, 1950.

On Ecology

Bates, Marston. *The Forest and the Sea*. New York: Random House, 1960.

Beston, Henry. *The Outermost House*. Garden City, N.Y.: Doubleday Doran, 1929; rep. Penguin Books, 1976. *Herbs and the Earth*. Garden City, N.Y.: Doubleday Doran, 1935. *White Pine and Blue Water*. New York: Farrar, Straus, 1950.

Burroughs, John. *Bird and Bough*. Boston, New York: Houghton Mifflin, 1906. *Birds and Poets*. Boston: Houghton Mifflin, 1885. *Wake-Robin*. New York: Hurd and Houghton, 1877.

Carson, Rachel Louise. *The Edge of the Sea*. Boston: Houghton Mifflin, 1955. *The Sea Around Us*. Rev. ed. New York: Oxford University Press, 1961. *The Sense of Wonder*. New York: Harper and Row, 1965. *Under the Sea Wind*. New York: Oxford University Press, 1952.

Eifert, Virginia. *Journeys in Green Places*. New York: Dodd, Mead, 1963.

Eiseley, Loren C. *The Immense Journey*. New York: Random House, 1957. *The Invisible Pyramid*. New York: Scribners, 1970. *The Night Country*. New York: Scribners, 1971.

Hough, Henry Beetle. *Singing in the Morning and Other Essays About Martha's Vineyard*. New York: Simon and Schuster, 1951.

Jefferies, Richard. *Field and Hedgerow*. London: Longmans Green, 1926. *Nature Diaries and Notebooks*. Billericay, Essex: Grey Walls Press, 1941. *The Old House at Coate*, ed. by Samuel Looker. Cambridge, Mass.: Harvard University Press, 1948. Rep. Freeport, N.Y.: Books for Libraries Press, 1970. *The Open Air*. London: Chatto and Windus, 1885, 1st ed. *Wild Life in a Southern County*. London: Smith, Elder and Co., 1879. *The Story of My Heart*. London: Longmans Green and Co., 1926.

Kirkland, Wallace. *The Lure of the Pond*. Chicago: H. Regnery, 1969.

Krutch, Joseph Wood. *Best of Two Worlds*. New York: W. Sloane Associates, 1953. *Great American Nature Writing*. New York: Sloane, 1950. *Great Chain of Life*. Boston: Houghton Mifflin, 1956. *Herbal*. New York: Putnam, 1965.

Leopold, Aldo. *A Sand County Almanac*. New York: Ballantine, 1970. New York: Oxford University Press, 1968.

Merriam, John C. *The Garment of God: Influence of Nature in Human Experience*. New York: Scribners, 1943.

Olson, Sigurd F. *The Hidden Forest*. New York: Viking, 1969. *Listening Point*. New York: Knopf, 1958.

Stanwell-Fletcher, Theodora C. *Driftwood Valley*. Boston: Little, Brown, 1946.

Thoreau, Henry David. *Cape Cod*. New York: Norton, 1951. *A Week on the Concord and Merrimack Rivers*. Boston: Houghton Mifflin, 1961.

Wyss, Max Albert. *Magic of the Woods*. New York: Viking, 1970. *Magic of the Wilderness*. New York: Viking, 1973.

Zwinger, Ann. *Beyond the Aspen Grove*. New York: Random House, 1970.

On Fiber and Fabric Techniques

Adrosko, Rita Janice. *Natural Dyes in the United States*. Washington: Smithsonian Institution Press, 1968.

Collingwood, Peter. *The Techniques of Rug Weaving*. Worcester, Mass.: Davis, 1968.

Dendel, Esther Warner. *Needleweaving Easy as Embroidery*. Garden City, N.Y.: Doubleday, 1972. *The Basic Book of Fingerweaving*. New York: Simon and Schuster, 1974. *African Fabric Crafts*. New York: Taplinger, 1974.

Held, Shirley E. *Weaving: A Handbook for Fiber Craftsmen*. New York: Holt, Rinehart and Winston, 1973.

Howard, Constance. *Inspiration for Embroidery*. London: B. T. Batsford; Newton Centre, Mass.: C. T. Branford, 1967.

Krevitsky, Nik. *Stitchery: Art and Craft*. New York: Reinhold, 1966.

Meilach, Dona Z. *Creating Art from Fibers and Fabrics*. Chicago: Regnery, 1972. *A Modern Approach to Basketry with Fibers and Grasses*. New York: Crown, 1974.

Rainey, Sarita. *Weaving Without a Loom*. Worcester, Mass.: David, 1968.

Robinson, Seonaid M. *Dyes from Plants*. New York: Van Nostrand Reinhold, 1973.

Willcox, Donald J. *New Design in Stitchery*. New York: Van Nostrand Reinhold, 1970. *New Design in Weaving*. New York: Van Nostrand Reinhold, 1970.

On Natural History

Armstrong, Edward Allworthy. *Birds of the Grey Wind*. London, New York: Oxford University Press, 1940.

Badenoch, L. N. *Romance of the Insect World*. New York, London: Macmillan, 1893.

Bannerman, David Armitage. *The Birds of West and Equatorial Africa*. Edinburgh: Oliver and Boyd, 1953.

Bent, Arthur Cleveland. *Life Histories of North American Blackbirds, Orioles, and Tanagers and Allies*. New York: Dover, 1965. *Life Histories of North American Wagtails, Shrikes, Vireos and Their Allies*. New York: Dover, 1950.

Clausen, Lucy. *Insect Facts and Folklore*. New York: Macmillan, 1954.

Comstock, John Henry. *The Spider Book*. Rev. ed. Ithaca, New York: Comstock, 1948.

Connold, Edward T. *British Vegetable Galls*. New York: Dutton, 1902.

Cooper, Susan Fenimore. *Rural Hours*. Syracuse, New York: Syracuse University Press, 1968.

Crook, John Hurrell. *The Evolution of Social Organization and Visual Communication in the Weaver Birds*. Leiden: E. J. Brill, 1964.

Darlington, Arnold. *Pocket Encyclopedia of Plant Galls in Color*. New York: Philosophical Library, 1968.

Felt, Ephraim Porter. *Plant Galls and Gall Makers*. New York: Hafner, 1965. Reprint of 1940 edition.

Grey, Edward Grey 1st Viscount. *The Charm of Birds*. New York: Frederick A. Stokes, 1927.

Hudson, William Henry. *Birds and Green Places*. A selection from the writings of W. H. Hudson by P. E. Brown and P. H. T. Hartley. The Lodge, Sandy, Bedfordshire, 1964.

Kelley, Elizabeth Burroughs. *With John Burroughs in Field and Wood*. South Brunswick, N.J.: A. S. Barnes, 1969.

Mani, M. S. *Ecology of Plant Galls*. The Hague: W. Junk, 1963.

Savory, Theodore Horace. *The Spider's Web*. London, New York: Warne, 1952.

Yaginuma, Takeo. *Spiders of Japan in Color*. Osaka: Hoikusha, 1960.